EASTBOURNE

From Old Photographs

ROY DOUGLAS

AMBERLEY

Acknowledgements

Many people have kindly helped with this book. My wife, Jean, has not only helped with criticism of the text, but has also helped me greatly with the intricacies of using a computer. My daughter, Alison Grover, and my son, Bruce, have similarly been of great help. I am exceedingly grateful to Helen Warren, who has provided numerous photographs and advice.

The photographs and other illustrations derive from several sources, and a number of people and organisations have kindly given copyright and usage permission. The main primary source was the wonderful collection at Eastbourne Central Library (ECL), I am very grateful to the people working there, notably Samantha Hide. My neighbour, John 'Sam' Attfield, has provided useful photographs. My thanks are due to Katherine Buckland at Eastbourne Town Hall (ETH), and also to the Eastbourne Heritage Centre (EHS), from which photographs were published in the *Eastbourne Herald*. Thanks are also due to the authors of the published sources herein used, and where possible I have sought and obtained permission to use the material.

If I have forgotten anyone to whom thanks are due, or unwittingly infringed any copyright or usage rights I extend my profound apologies.

First published 2014

Amberley Publishing
The Hill, Stroud,
Gloucestershire, GL5 4EP

www.amberley-books.com

Copyright © Roy Douglas, 2014

The right of Roy Douglas to be identified as the Author of this work has been asserted in accordance with the Copyrights, Designs and Patents Act 1988.

ISBN 978 1 4456 3322 0 (print)
ISBN 978 1 4456 3336 7 (ebook

British Library Cataloguing in Publication Data.
A catalogue record for this book is available from the British Library.

Typesetting by Amberley Publishing.
Printed in Great Britain.

Introduction

Old photographs are useful in understanding the character of any town, but for Eastbourne they are particularly valuable, as the town we know today is mainly a development from the late nineteenth century onwards. So there are plenty of photographs available to show the scope of development. To some extent, it has proved useful to supplement photographs with other illustrations, but photographs have been the principal source in this book.

In the mid-nineteenth century, what is now Eastbourne was a collection of villages, with an overall population of around 3,000. The great public interest in the coast, which became so marked in later times, had still not developed fully, and most people in the parish lived a mile or so from the sea. The 1841 census showed that in most parts of Eastbourne, including the built-up district, the principal male occupation was agricultural labourer, and the principal occupation of employed women was female servant, which usually meant domestic servant.

A key principle was established early in Eastbourne's nineteenth-century development, and is still visible in the modern town. It was a rather select place with good-quality housing, hotels, and plenty of open spaces. The first stages in the development of Eastbourne as a resort took place at a time when the only people who could afford to visit the seaside for pleasure were affluent. That did not apply for much longer, and well before the end of the nineteenth century, provision came to be made for a much wider range of people. Early photographs give a good idea of how, where and when the great changes were taking place.

In the nineteenth century, there was growing public interest in seaside places, and rapid improvements in communication. For Eastbourne, this began with the arrival of the railway in 1849. Soon, more and more people living far away became able to afford a week or fortnight holiday, or at least the occasional day trip, to a seaside town such as Eastbourne. For the remainder of the nineteenth century, the railway would be by far the most important means of access to Eastbourne from the outside world. It wasn't until the twentieth century that motor transport, whether public or private, acquired similar importance.

As with most towns, the physical appearance of Eastbourne has been influenced by the local geology. There is little suitable building stone. Chalk, which is present in enormous quantities, is not suitable for construction. Upper Greensand, quarried on the beach, was once of local importance but the supply is now limited. It was used, along with other materials, in St Mary's church and Pevensey Castle. The best the immediate vicinity can yield in abundance is flint, which is found in some parts of the chalk and in the overlying clay-with-flints, which is itself derived from the chalk. Today, the use of flint is largely decorative, but in the past it was frequently used in the structure of buildings. Some of the old buildings, like the Lamb Inn, were timber-framed. It is possible to obtain good-quality building stone from far

off, but that is necessarily an expensive process. The majority of modern buildings in and near Eastbourne are made largely of bricks and cement.

A question which has vexed the author and which may already be vexing the reader is; what do we mean by 'Eastbourne'? The ancient parish? The borough as first constituted in the 1880s? The modern borough? The present-day parliamentary constituency? These each cover different areas. The author has decided to understand Eastbourne to be the area covered by the current *A to Z Street Guide*, with the exception of Hailsham and points north thereof, which are clearly separated by countryside. In this definition, we include Pevensey, Willingdon and Polegate, but exclude places such as Folkington, with its lovely old church, and Wilmington with remains of its priory, and the famous 'Long Man' carved into the hillside. It is an arbitrary definition, but the line must be drawn somewhere.

1

Before Modern Eastbourne:

The Old Town

Until the mid-nineteenth century, anyone who thought about Eastbourne would probably not have considered the places near to the sea, which are familiar to the modern holidaymaker. Instead, the term referred to the region which is called the Old Town, centred on the large parish church of St Mary's, about 1 mile from the sea. The Old Town would have ranked as at least a large village, perhaps even a small town.

This chapter will consider mainly of the Old Town, the part which was originally known as Bourne. Not only was the Old Town the most important part of Eastbourne in earlier times, but it was little affected by the earliest phase of development, and so there are plenty of photographs, taken later, which show an almost unchanged Old Town.

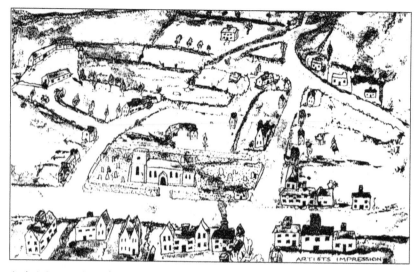

Artist's Impression of Bourne, 1631

Bourne (the Old Town of Eastbourne) was the largest of the villages from which modern Eastbourne grew. This rather crude sketch, drawn in the reign of Charles I, shows a number of features which are still recognisable today. The street plan has not greatly changed. St Mary's church and the Lamb Inn are both still in place. Jesus House also appears, and survived until the development period was already under way.

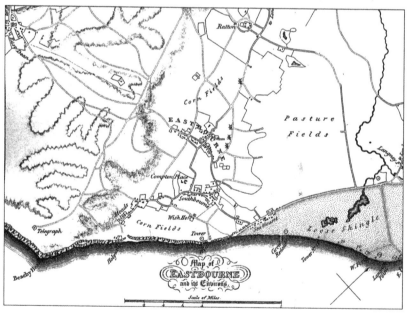

Eastbourne, 1819, From John Heatherley, *A Description of Eastbourne and its Environs*

John Heatherley's early nineteenth-century book was a sort of visitors' guide, and this map was probably designed to attract visitors. The map gives an idea of the principal centres of population before the nineteenth-century development began. The name Eastbourne, often written as two words, is sometimes used for the whole parish, or to contrast the Old Town with the district of South Bourne, centring on South Street. The hamlets of Sea Houses, Meads and Holywell are also marked. (*ECL*)

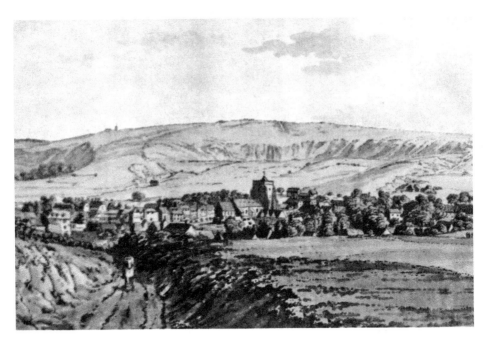

View from Watts Lane, 1785

Watts Lane, from which this drawing was made, was little more than a muddy footpath in the eighteenth century. The earlier sketch of Eastbourne Old Town was drawn from the south, looking north. This drawing, from roughly the opposite angle and produced 150 years later, shows Eastbourne's relationship to the Downs near Beachy Head. St Mary's Church is still the dominant building and would be easily recognisable today. Immediately in front of the church tower is the Old Parsonage, with its three side gables. To the left of the church is the Lamb Inn. (*ECL*)

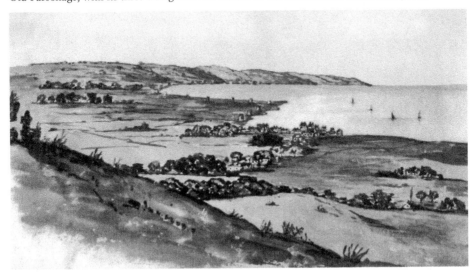

Eastbourne from the Downs, 1835

More than one local clergyman has provided useful insights into the appearance of early Eastbourne. The Revd Cyril Page illustrated the coast, as seen from near the Old Town. The hamlet of Sea Houses and the line of Martello Towers (which will be considered later) are clearly seen, as are the fields on which a large part pf modern Eastbourne was built. (*ECL*)

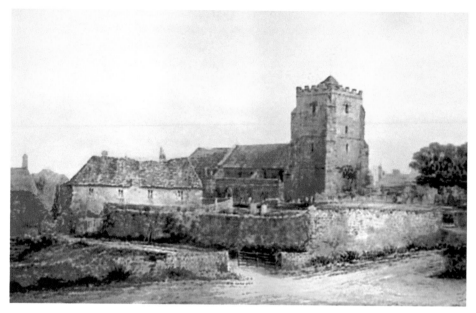

St Mary's Church, in the Late Eighteenth Century
The oldest existing building in Eastbourne dates from around 1160, and is constructed largely of Caen stone, which was imported from Normandy at what must have been considerable cost. There is also some Upper Greensand, which was almost certainly obtained locally. The church was substantially altered in the fourteenth century. (*ECL*)

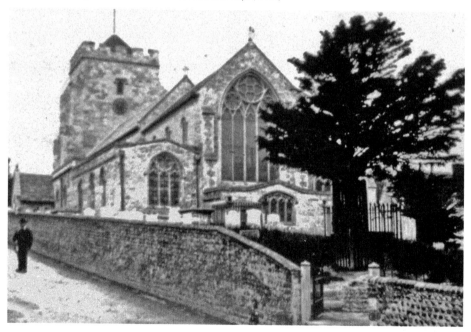

St Mary's Church in the 1870s
In the 1870s, St Mary's church still looked much as it had done in earlier times, although there had been some restoration. As we shall see, enormous changes had already taken place in other parts of Eastbourne, but the Old Town and its ancient church were relatively unaltered. (*ECL*)

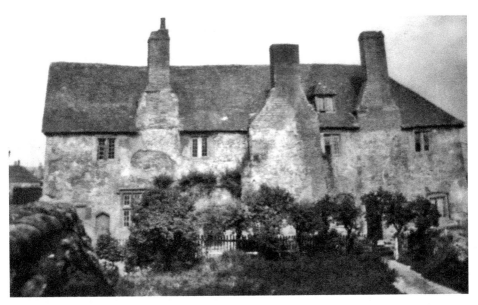

The Old Parsonage, 1902
A parsonage, or vicarage, may be seen near the church on the 1631 drawing. This building was partially, or wholly, replaced by another, which is illustrated here. Successive incumbents appear to have found the building unsatisfactory, and it was later demolished. (*ECL*)

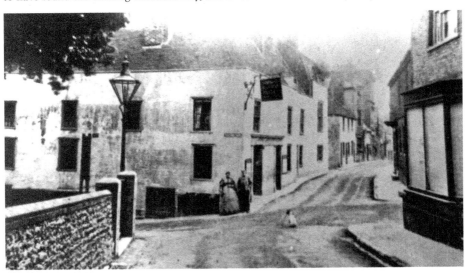

The Lamb, 1865
Old Eastbourne had two social centres (the church and the main pub) and these were located close together. The Lamb Inn dates from the fourteenth century. As with many Sussex buildings of the period, the absence of good, local building stone resulted in the use of timber framing for the main structure. Most timber-framed buildings in Eastbourne have long disappeared, but the Lamb remains. Today, the timber framing is emphasised for aesthetic reasons, but in earlier times tastes were different, and the structural timbers were masked by plaster. This photograph shows the Lamb before it was renovated in 1912, and the old timbers were exposed. The Lamb has been linked with stories of smugglers, and a mysterious tunnel to the church, but these do not seem to have much factual foundation. (*ECL*)

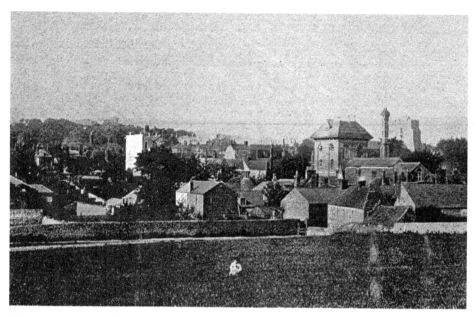

The Star Brewery, Old Town, *c.* 1880
At a time when transport costs for bulky items like barrels of beer were considerable, Eastbourne, like most large villages or small towns, had its own brewery. (From Lawrence Stevens, *A short History of Eastbourne*. Eastbourne Local History Society, 1987)

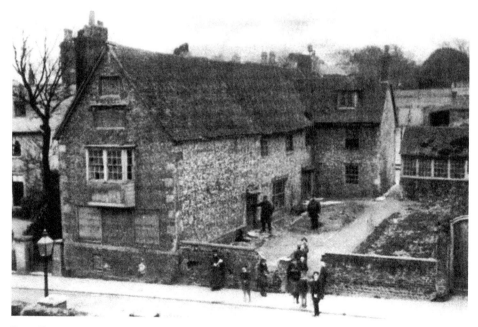

Jesus House
Long before the arrival of national insurance, the 'Brotherhood of Jesus' was a sort of guild for working men, which provided financial help when needed. This photograph of Jesus House was probably taken from St Mary's church tower, by the incumbent, the Revd Walter Budgen, a keen amateur photographer who took many pictures of his parish.

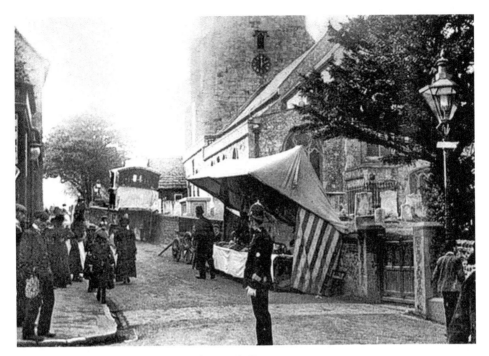

Church Street and High Street, Late Nineteenth Century
Church Street and High Street run into each other, by St Mary's church. In the nineteenth century, both were considerably narrower than today, but, as now, they were dominated by the church. One of the photographs shows a market stall and a policeman in an old uniform. Policemen on the beat were much more in evidence than they are now. In the other, a man (almost certainly an agricultural labourer) is wearing a smock; a garment once general for men of his occupation.

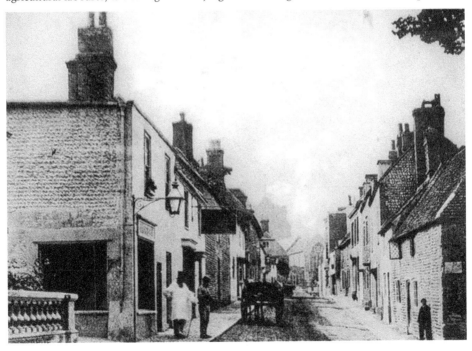

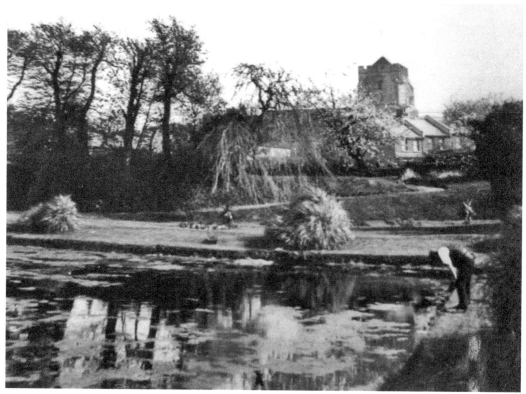

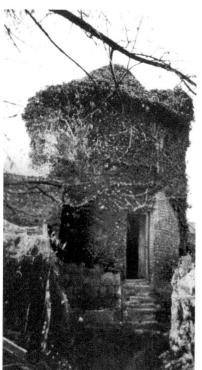

Above: Motcombe Gardens Pond, Early Twentieth Century
The Bourne from which Eastbourne derives its name rises
in the pond in Motcombe Gardens, a small public park in
Old Town, which was given to the town by the 9th Duke
of Devonshire in 1909. St Mary's church can be seen in the
background. (*ECL*)

Left: Dovecote, Motcombe Park, *c.* 1910
Many landed estates had dovecotes, as the landowner
and his household ate the doves and their chicks (squabs).
Dovecotes were often highly unpopular with local people,
for the birds fed on grain in the villagers' fields. This
dovecote is one of the oldest structures in Eastbourne.
Parts of it date from the fourteenth century. (*ECL*)

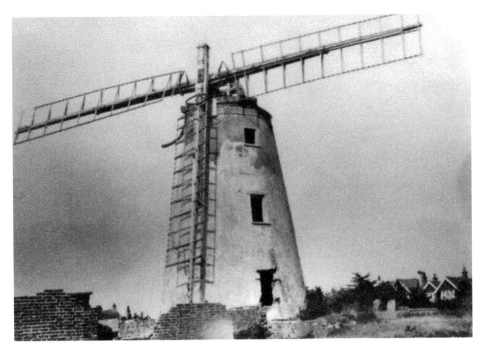

Ocklynge Mill, 1930
Windmills for grinding grain were a prominent feature of old Eastbourne. Some persisted for a long time, and others, a few miles from the town, are still in working order today. Ocklynge Mill, which had lost one of its sails and was therefore no longer functional when this photograph was taken in 1930, was a late survivor in the immediate Old Town vicinity. (*ECL*)

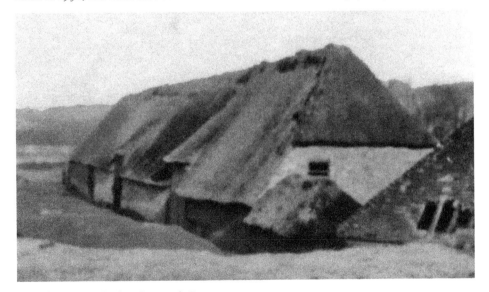

Motcombe Barn, in the Nineteenth Century
Another sign of the originally rural character of the Old Town was Motcombe Barn, which survived into the era of photographs. As with many old buildings of the area, its walls were made of flint, which was used for constructional rather than decorative purposes, while the roof was thatched. (*ECL*)

Gildredge House, *c.* 1900
The Gilbert family were Lords of the Manor of Eastbourne, and were to play an important part in the development of the future town. Gildredge House was owned by the family for many years, though it was never the Manor House. It later had a varied history, and was for a time the home of the Towner Gallery and a local museum. It is now used as a venue for weddings and parties. (*ECL*)

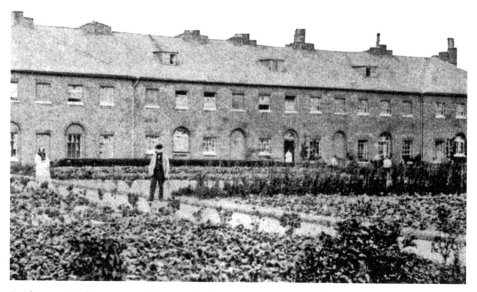

Eastbourne Workhouse, Late Nineteenth Century
One of the least attractive features of old Eastbourne was the Dickensian workhouse. The building had a remarkable history. It was constructed in the late eighteenth century as a cavalry barracks during the French wars. After the conflict, it became a poor house, and in 1834 became the Union workhouse for a group of parishes. It was later renamed a Poor Law Institution. In 1930, its use was again changed. Until its destruction in 1989, it functioned as St Mary's Hospital. The site is now a housing development.

2

Before Modern Eastbourne:

The Other Parts

The main early development of Eastbourne took place in parts nearer to the sea than the Old Town, particularly in the parts lying immediately to the west of the present pier. There are a number of photographs and other illustrations in existence that give a fair idea of how most of the parts beside the coast, or not far from it, appeared before the nineteenth-century development began.

Three main settlements existed outside the Old Town. In and around South Street was a small village, sometimes called Southbourne, separated from the sea by cornfields. Just east of the site of the present pier was a hamlet known as Sea Houses, whose inhabitants were concerned with agriculture and fishing. To the west of Southbourne was a group of farms known collectively as the Meads. The Meads came to the sea at Holywell (pronounced Holly-well) at the foot of the great chalk promontory Beachy Head.

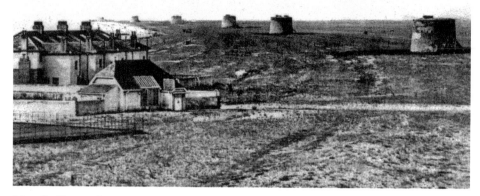

Martello Towers, Pevensey Bay

The feature that would probably have first struck the casual visitor to the Eastbourne coast before 1850, was the line of Martello Towers that extended along much of England's south and east coast. These towers had been built as fortifications at the beginning of the nineteenth century, at a time when there was a serious fear of invasion from Napoleonic France. They were of solid masonry, and each contained rooms for a garrison of thirty men. This comparatively modern photograph of the south-easternmost part of Eastbourne gives an idea of how they were originally arranged. Today, many of the Martello Towers have been destroyed, but some still remain.

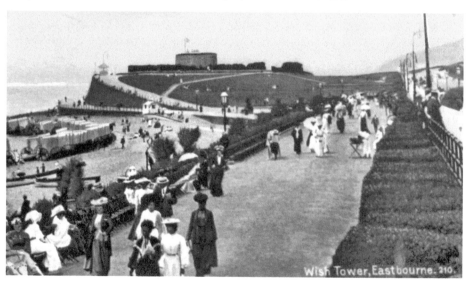

Wish Tower, Postcard from 1908

The most familiar Martello Tower to the modern Eastbourne visitor is tower No. 73, known as the Wish Tower. The name has nothing to do with wishing, for 'wish' originally meant a piece of marshy meadow. Near the tower was once a large, stagnant pool fed partly by drainage water from nearby fields, and partly by salt water oozing through the shingle. Apart from peoples' clothes and the old-fashioned 'bathing machines', this picture postcard of the Wish Tower and promenade, which was issued more than a century ago, could almost have been taken today. (*ECL*)

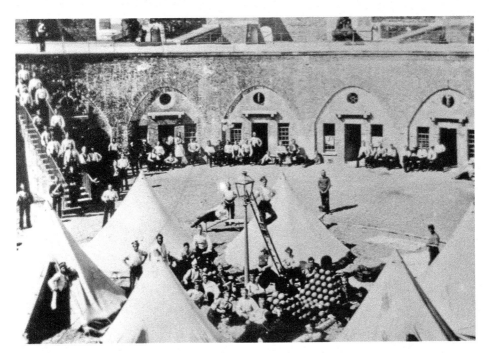

The Redoubt

During the French wars, the Redoubt was constructed in the eastern part of the seafront as a fort and depot for the Martello Towers. John Heatherly's *Description of East-bourne*, published in 1819, described it as 'an enormous battery of eleven guns, bomb-proof, capable of containing 350 men, with provisions, water, etc, for a length of siege'. The Redoubt has been used for military purposes more recently, shown in this photograph from the turn of the twentieth century. (*ECL*)

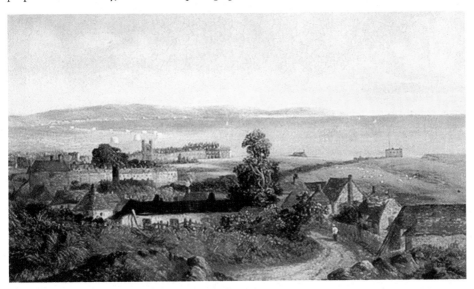

Eastbourne from the Meads, Watercolour From the 1850s

This watercolour brings out several features of Eastbourne just before major development began. The Meads, from which it was painted, was an agricultural hamlet. Many Martello Towers may be seen in the distance.

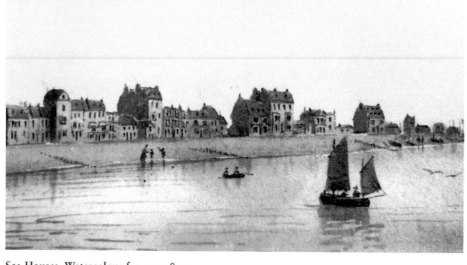

Sea Houses, Watercolour from *c.* 1830
The attractive little fishing port of Sea Houses, just east of the present pier and following the line of the modern thoroughfare called Seaside, is shown before the nineteenth-century development began. (*ECL*)

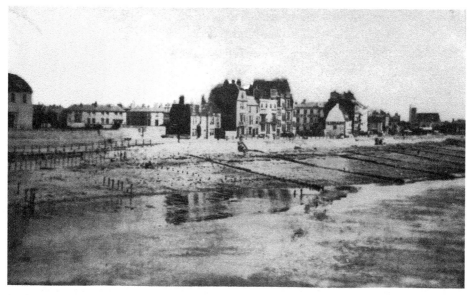

Sea Houses, 1875
By the date of this photograph, many great changes had already taken place a short distance from this site. A few changes had already occurred at Sea Houses, but the general scene, which was probably photographed from the new pier, is not very different from the old watercolour. The library, which existed long before development began, is to the right of centre. The tall houses in the centre are the original Sea Houses. Field House, which was pulled down three years later, is at the left of the picture. (*ECL*)

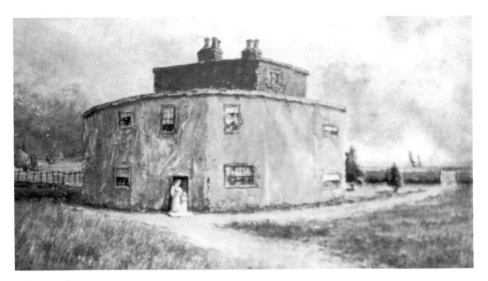

The Round House, 1840

Although public interest in the seaside was rather late to develop, early encouragement was afforded by George III and his family. The King's association with Weymouth, and the association of two of his sons with Brighton, are famous. Less well known is the visit paid by his young son, Prince Edward, (later to become the father of Queen Victoria), to Eastbourne in 1780, along with three of his siblings. The prince stayed at the Round House in Sea Houses near the entrance to the modern pier. As shown in this old painting, the Round House was the lower part of a rather unusual structure known as a horizontal windmill, which had been converted into a residence in the mid-eighteenth century. Threatened by encroachment from the sea, it was demolished in 1841. (*ECL*)

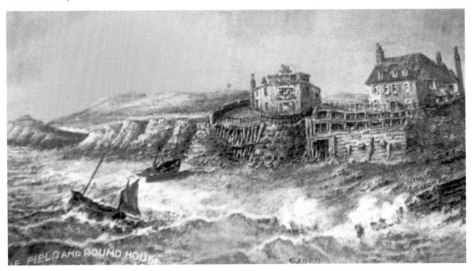

Field and Round Houses, 1840

Another painting from 1840 brings out a different point. The whole scene is close to the present pier's head. The coast is obviously prone to encroachment by the sea, and it is easy to visualise what it would have been like on a stormy winter's day. Nor is it difficult to see why Round House, and eventually Field House, had to be demolished. When the major reconstruction of the area took place in the following decades, one important change, that has perhaps not attracted as much attention as it deserves, was a great strengthening of the sea defences. (*ECL*)

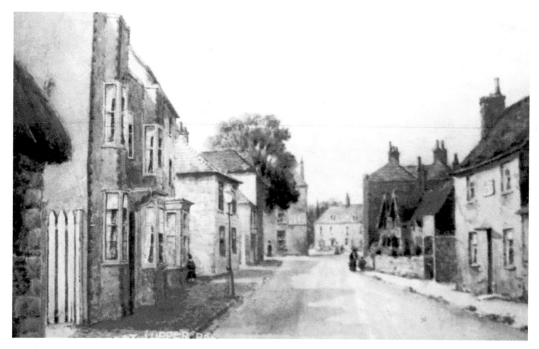

South Street, 1870

Before development of Eastbourne began, the most populous area, apart from the Old Town, was Southbourne, around South Street. As late as 1870, South Street was still a rural thoroughfare lined by cottages which (at least from the exterior) appear very attractive. (*ECL*)

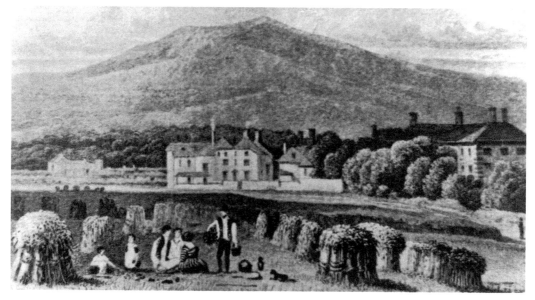

South Street, Engraving From *c*. 1850

At the end of South Street, there was nothing to show that major development would soon take place. This old engraving may be somewhat idealised, but it presents a thoroughly rural scene with a farm worker and his family picnicking in a cornfield. Corn was grown in much of the area, as the modern names of Cornfield Lane, Road and Terrace suggest. (*ECL*)

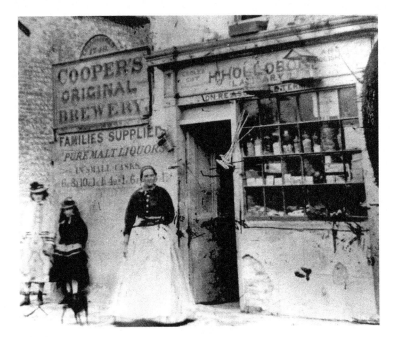

Shop in South Street
Rather dilapidated small shops still existed when active development had begun a short distance away. The owner of this shop, Harry Holloborn, whose wife Mary is shown here, was described as a lapidary, and later set up a stone museum in the Wish Tower. This photograph was probably taken a decade or two after the previous engraving. (*ECL*)

Coach Office, Greystone House, South Street
Immediately before the arrival of the railway, the main link from Eastbourne to the outside world was by coach. There were several coach services. A good example of the kind of service provided is given in Heatherington's book from 1819. He noted that 'a coach leaves the Sea-houses every morning, except Saturdays, for London, at eight o'clock'. It arrived at Charing Cross at 5.30 p.m., a journey of 9½ hours. (*ECL*)

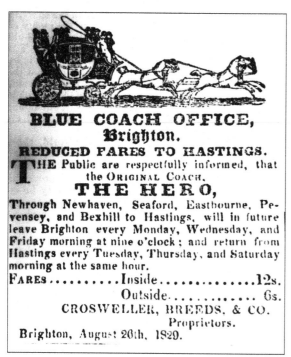

BLUE COACH OFFICE,
Brighton.

REDUCED FARES TO HASTINGS.

THE Public are respectfully informed, that the ORIGINAL COACH,

THE HERO,

Through Newhaven, Seaford, Eastbourne, Pevensey, and Bexhill to Hastings, will in future leave Brighton every Monday, Wednesday, and Friday morning at nine o'clock; and return from Hastings every Tuesday, Thursday, and Saturday morning at the same hour.

FARES Inside 12s.
Outside 6s.

CROSWELLER, BREEDS, & CO.
Proprietors.

Brighton, August 26th, 1829.

Blue Coach Office Handbill, 1829
Coach journeys through Eastbourne were both expensive and uncomfortable. This handbill from a Brighton company serving Eastbourne gives some idea of what they were like. Six shillings (30p) for an outside trip from Brighton to Hastings sounds cheap today, but it must be remembered that there has been massive inflation since then, and the sum would have represented several days' pay for an agricultural labourer in the early nineteenth century. Travelling outside the coach would have been extremely uncomfortable in bad weather, and even a journey inside, on the appalling roads of the time, would hardly have been pleasant. Before the railway arrived, most residents would seldom have ventured far outside Eastbourne, unless they had very good reason for doing so. (*ECL*)

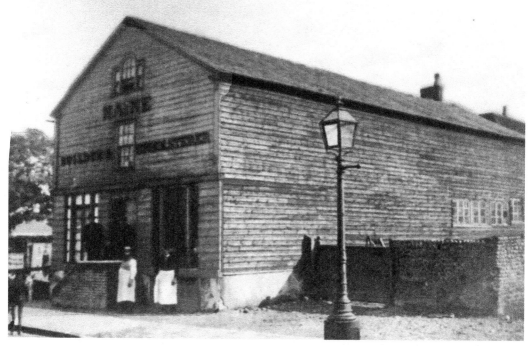

Old Theatre, South Street, *c.* 1880
In 1798, Eastbourne acquired a theatre in South Street, which remained in use for many years. It appears to have been open for about two months in the year, with a local company performing, occasionally supplemented by players from London. (*ECL*)

Stocks Bank
Small local banks were common in the early part of the nineteenth century, and Stocks Bank, which was situated where the town hall now stands, was a typical example. (*ECL*)

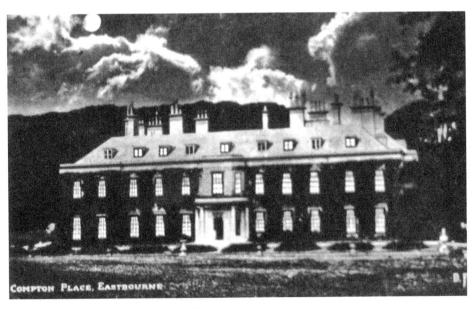

Compton Place, Night View. Postcard from 1909
Compton Place was at the western end of Southbourne. In the mid-nineteenth century, it was the seat of the 2nd Earl of Burlington, who later succeeded a relative as 7th Duke of Devonshire. It is likely that his experience there was of considerable importance in encouraging him to favour the development of Eastbourne. (*ECL*)

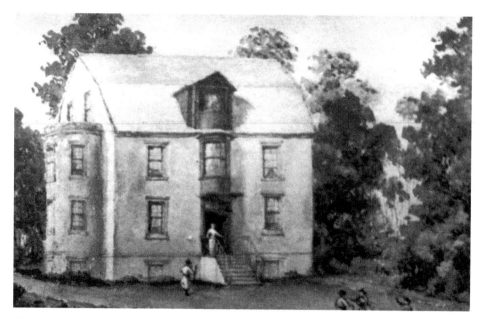

The Grove

Grove Road, one of the principal roads in Eastbourne, is named after a house (originally a residence but later a school) that once stood there. A later illustration will show its demolition many years later. (*ECL*)

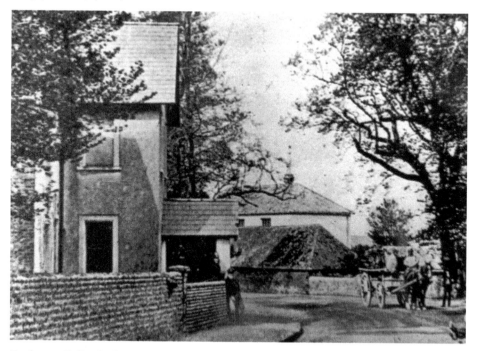

Eastbourne Police Station, 1875

When modern policing began, Eastbourne had no separate police force, but was policed by the county force from Pevensey; a more important town at the time. However, in 1842, Eastbourne acquired a constable of its own and, as time went on, a regular police station was established. (*ECL*)

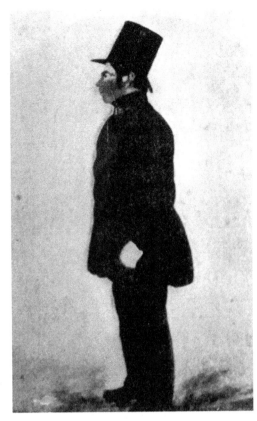

Right: Joe Carter, Eastbourne's First
Police Constable, *c.* 1891
Well before Eastbourne began its
nineteenth century development, a police
constable was appointed for the little
town. As Eastbourne grew, so rapidly did
its police force. (*ECL*)

Below: View From Meads Road, *c.* 1870
Today the Meads is a rather select
residential area. The main development
there began late in the nineteenth century.
As this photograph shows, the Meads area
remained very rural, even when substantial
development had taken place in other
parts of Eastbourne. (*ECL*)

Holywell House, *c.* 1855

A very old and blurred photograph shows Holywell House, close to the foot of Beachy Head at the south-western end of Eastbourne. The name derives from a sacred spring, said to have therapeutic properties, which rose nearby. (*ECL*)

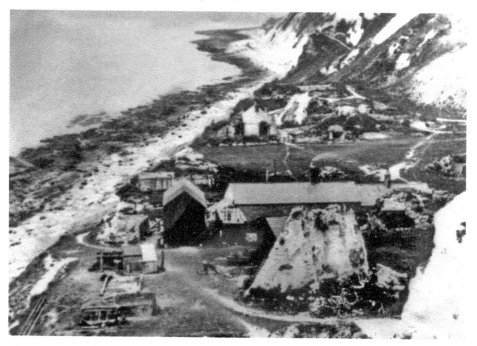

Lime Kiln and Stables, Holywell

Industrial activity operated at Holywell until the end of the nineteenth century. Chalk was quarried at the foot of Beachy Head and heated to yield lime, which was important in agriculture and construction. (*ECL*)

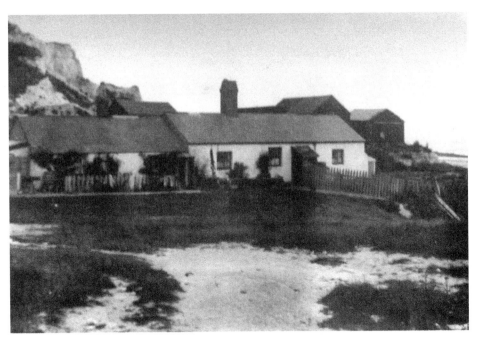

Boat Houses and Cottages, Holywell Pumping Station, 1880
Fishermens' cottages were still in use at Holywell in the late nineteenth century, although they have long-since disappeared. An innovation was the pumping station, which was developed by the Eastbourne Waterworks Company. (*ECL*)

Ratton Manor, *c.* 1885
In much of the Eastbourne area, the old agricultural pattern persisted long after development of the seaside town was under way. The landed squire lived in a big house, of which Ratton Manor is a good example, with a retinue of servants. Deferential tenant farmers rented their holdings from him. In turn, they were served by landless farm labourers, who performed hard, exacting work for which they were paid a pittance. (*ECL*)

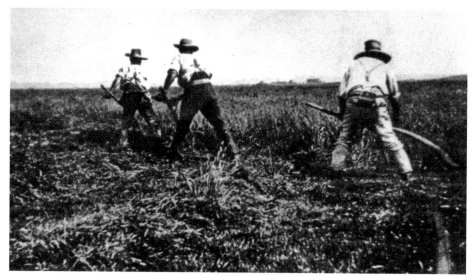

Scything, Early Twentieth Century
Before the nineteenth-century development, agriculture was a major occupation in Eastbourne. Farming practices sometimes remained primitive to a later date. Many of the farms were too poor to make use of the expensive, but more efficient, modern equipment that was available. Haymaking and grain reaping were largely performed manually. Some photographs from the late nineteenth and early twentieth centuries, give an idea of what agriculture was like everywhere in the district a few decades earlier. (ECL)

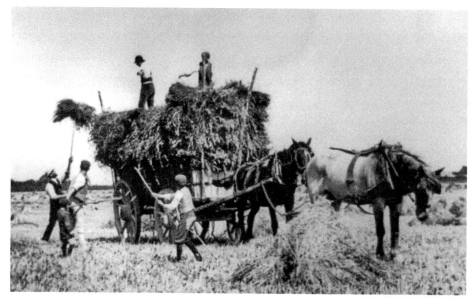

Agricultural Labourers Loading a Horse-Drawn Cart, Early Twentieth Century
In the nineteenth century, and well into the twentieth century, much of what is today 'urban Eastbourne' was still devoted to farming. Agriculture was highly labour-intensive, and operations which today would usually be performed by one person and a machine, commonly required several men and horses. Agricultural labourers were notoriously badly paid, particularly in places like Sussex where there was not much industry competing for their services. (ECL)

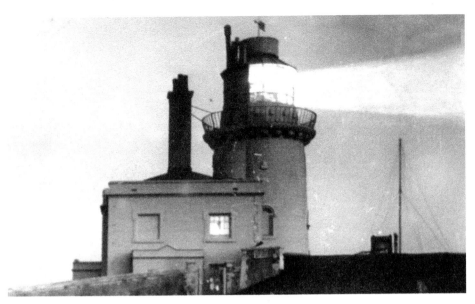

Belle Tout Lighthouse in Action, *c.* 1900
Beachy Head, the great chalk cliff to the west of Eastbourne, was notoriously dangerous for ships. The lighthouse at Belle Tout on Beachy Head was already functioning in the 1830s. A second lighthouse was later constructed out at sea as a replacement, but the old building remains. It was eventually moved further back from the cliff. (*ECL*)

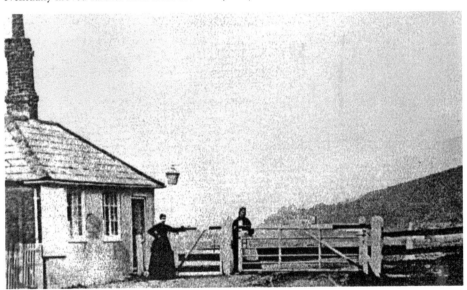

Southerham Gate Toll House, 1865
A rather short-lived feature of old Eastbourne was the provision for tolls on the turnpike road, which gave access to Lewes. This photograph of a toll house was taken some distance from Eastbourne. Tolls began to be collected in 1820. With the arrival of the railway, turnpikes became of diminishing importance, and the trust which operated them expired in 1879. (Eastbourne Local History Society, *Turnpike Territory: the Glyndebourne Trust and the Lewes to Eastbourne Turnpike*, 2007, with kind permission of Peter Tyrrell)

3

Changing Eastbourne

In the mid-nineteenth century, two developments began, which together would have an enormous influence on the future of Eastbourne. First, the railway arrived. Shortly afterwards, buildings designed to establish an important new seaside resort began to be constructed, near the seafront. The early development of the town was greatly influenced by the 7th Duke of Devonshire and his agents. The duke, who had enormous and scattered territorial interests, also played a major part in turning Barrow-in-Furness, Cumbria, from a hamlet into an important industrial town and exerted considerable influence on Buxton, which was much closer to his Derbyshire seat at Chatsworth.

From the mid-nineteenth century onward, the railway and resort greatly influenced each other. At a time when motor vehicles were unknown, and visits from far away were difficult, tedious and expensive, railway communications made travel much quicker, and soon much cheaper. In response, the town began to grow rapidly, which encouraged further railway improvement. Other changes were taking place in various parts of Britain, which also had a massive effect on Eastbourne. More and more outsiders were becoming interested in visiting the seaside, and were acquiring the economic means to indulge that desire.

All these changes must have greatly affected the lives and livelihoods of many people living in old Eastbourne. What happened to them is a matter of real importance, but this book is not the place to study their fate.

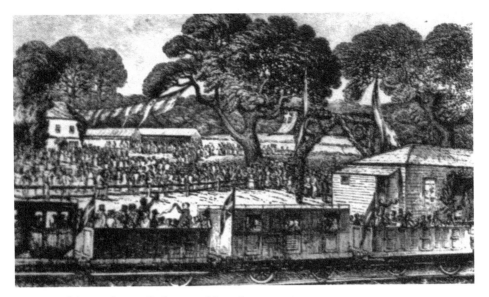

Opening of the Eastbourne Railway, 14 May 1849
In 1841, the railway between London and Brighton was completed and, in 1846, a line from Brighton to Hastings was constructed. That line did not take the route via Newhaven, Seaford and Eastbourne that the stage coaches had followed, but instead ran via Lewes and the hamlet of Polegate. Apparently, Eastbourne was not yet considered a place of much importance. However, in 1849, a branch line was established from Polegate to Eastbourne. The arrival of the railway was greeted with much local jubilation, as this print suggests. (*ECL*)

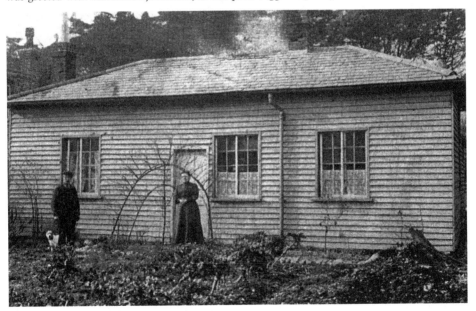

Eastbourne's First Railway Station in Retirement
The original station building at Eastbourne was a simple wooden affair, part of which may be seen to the right of the previous picture. It survived as a dwelling house for a number of years after its original purpose had been superseded. (*Lawrence Stevens*, A Short History of Eastbourne. *Eastbourne Local History Society, 1987*)

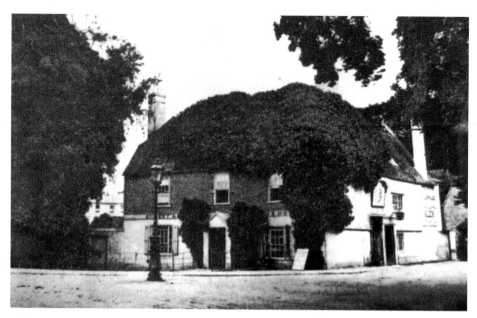

Gilbert Arms, c. 1865
The existence of a railway station led to the establishment of a pub for thirsty travellers. A former farm house on the Gilbert estate, conveniently close to the new station, was selected. It was at first officially named the Gilbert Arms, and later the Terminus Hotel. It was known by locals as 'The Squirrel', because a squirrel appeared on the armorial bearings of the Gilberts. (*ECL*)

Second Eastbourne Railway Station, 1871
The original railway station building, which had been not much more than a shed, lay a little to the west of the present terminus. It was soon replaced by another building, which was nevertheless much less impressive than the one we know today. (*ECL*)

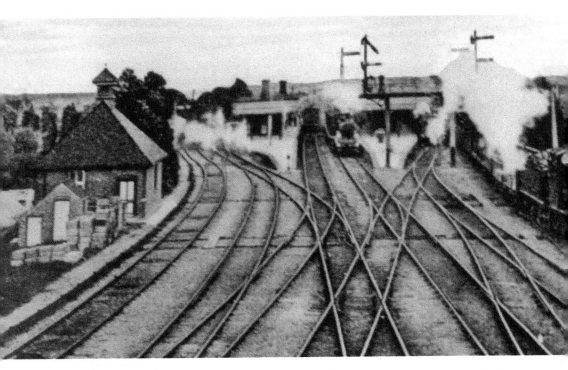

Above: Polegate Station,
Around 1920s or Early 1930s
For a number of years after Eastbourne received
a railway station, the station at Polegate (5 miles
to the north) was the junction where visitors to
Eastbourne needed to change trains. There was
also another railway branch from Polegate, now
closed, but largely represented by the Cuckoo
Trail, leading northwards to Hailsham and
beyond. This twentieth-century photograph
shows the original station at Polegate as a busy
junction. (*ECL*)

Right: Third Railway Station and the 'Eastbourne
Express'
In the late nineteenth century, a third railway
station was built. A postcard sent in 1908
shows the concourse in a form which would
be easily recognised today. Communications
were improving as well, and the 'Eastbourne
Express' greatly sped up the journey to
London. Throughout the nineteenth century,
and into the early twentieth century, visitors to
Eastbourne from distant places would nearly
always have travelled by rail. (*ECL*)

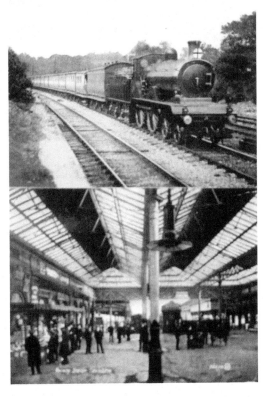

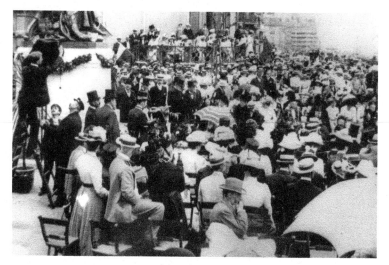

Unveiling the Statue of the 7th Duke of Devonshire, 17 August 1901
'No ordinary duke' would be a fair judgement on William Cavendish. No doubt Eastbourne would have developed as a seaside resort without his influence, but it would be a very different place today. After an impressive career as an undergraduate, and a brief period in the House of Commons, Cavendish succeeded his grandfather as 2nd Earl of Burlington in 1834, with his seat at Compton Place, Eastbourne. In 1858, he succeeded a more distant relative as 7th Duke of Devonshire. The development of Eastbourne had begun before Cavendish succeeded to the dukedom, but the work entered its most important phase shortly after he obtained the great resources associated with his new rank. No doubt the Eastbourne development proved profitable to the duke, but he made very substantial donations of land and money, which appear to have been altruistically inspired. The duke was much appreciated in Eastbourne, and a large crowd gathered to witness the unveiling of his statue, ten years after his death. (*ECL*)

The Old Orchard, with Robert Insoll, 1875
The owner of this substantial house, who is shown standing in front, was Robert Insoll, Eastbourne agent of the Duke of Devonshire for many years. He also played an important part in the early development of the town. In 1889, the house was pulled down to make way for shops in Grove Road. (*ECL*)

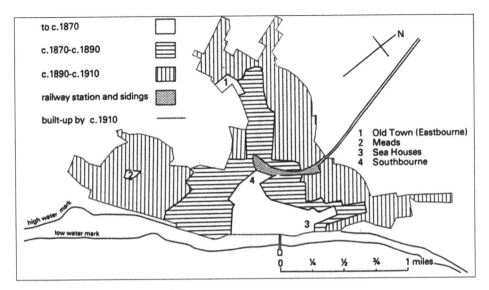

Chronology of Eastbourne Development

By 1870, there had been massive development along the seafront and roads leading from it; more or less linking Southbourne and Sea Houses, but still stopping short of the Old Town and Meads. By 1890, there had been expansion in all landward directions, and the Old Town had been reached by new buildings. Much of the first part of the nineteenth-century development took place on lands belonging to the Duke of Devonshire. (David Cannadine, *Lords and landlords: the aristocracy and the towns 1774–1967*. Leicester U.P. 1980)

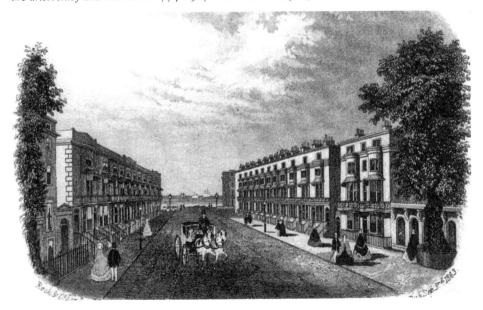

Cavendish Place, 1863

This etching shows one of the principal streets leading to the seafront. The houses are all substantial, and the people parading the street are obviously well-off. No doubt they had brought servants with them, who were working industriously indoors, and were served by tradesmen living in poorer parts of the town. The days were not far off when people of lower social classes would also be able to afford visits to Eastbourne.

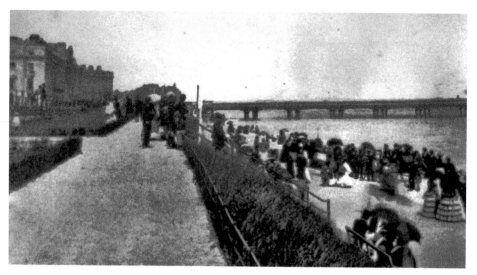

Grand Parade in the 1870s

By the 1870s, further big changes were taking place. This photograph of the Grand Parade shows the new pier, which was commenced in 1870, and also a considerable crowd. The people are all respectably dressed, but many of them do not appear to be as wealthy as those shown in the preceding sketch. In the 1850s, 1860s and the first part of the 1870s, people from all social classes were enjoying increasing prosperity. Seaside holidays were rapidly becoming accessible to a much wider group of people. (*ECL*)

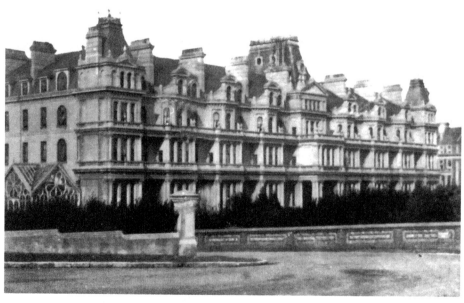

Grand Hotel, Late Nineteenth Century

Numerous hotels were built along the seafront during the late nineteenth century. Some, including the Grand Hotel, would still be recognisable today. What has changed enormously, however, are the facilities provided. When the Grand was built in 1877, it had only six bathrooms for 200 bedrooms. Even well-heeled Victorians were less interested in personal hygiene than people are today. (*ECL*)

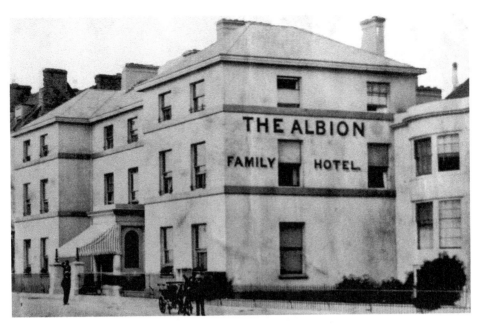

Albion Hotel, Before 1897
Even before the mid-nineteenth-century development of Eastbourne began, the Albion Hotel was in existence in what was then called the Sea Houses. Part of the building dates to 1821. It responded to the new development, and is reputed to be the first hotel which was equipped with electricity and telephone. (*ECL*)

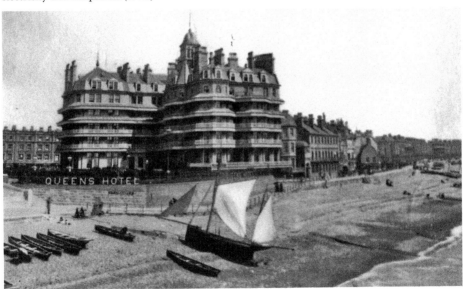

Queen's Hotel and Buildings to the East, in the Late Nineteenth Century
Big changes soon took place east of the pier. High-class developments extended as far as the Queen's Hotel. But Eastbourne was a rapidly growing town, and interest in seaside visits was permeating all social classes. Further to the east, cheaper hotels and boarding houses began to appear, as this picture shows. As time went on, and much rebuilding took place, the social difference gradually disappeared. (*ECL*)

Assembly Rooms and a Brewery, Seaside, 1870
Provision was made for social activities in the Assembly Rooms of Eastbourne at an early date. The part to the left of this photograph later developed as Debenhams, and to the right became the Southdown bus depot.

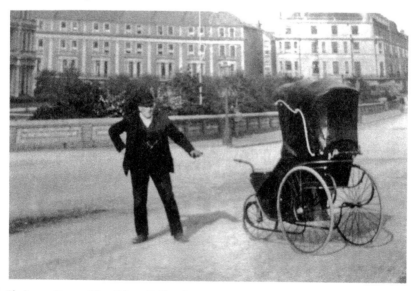

Bath Chairs on Future King Edward's Parade, *c.* 1890.
Just as Eastbourne was developing eastwards along the seafront during the late nineteenth century, so also was the town developing westwards in the direction of Holywell. This photograph shows bath chairs. These were much used by visitors to the town. George Meek, an Eastbourne resident and a friend of H. G. Wells, wrote bitterly, 'If you would know the horror of black despair go out with a bath chair day by day, with the chair owner or landlord worrying you for rent ... and get nothing...' Some licence plates for these bath chairs still exist, for example near the Wish Tower. They are marked BCS (bath chair stand). (ECL, see also George Meek, *Bath Chair Man*, 1910)

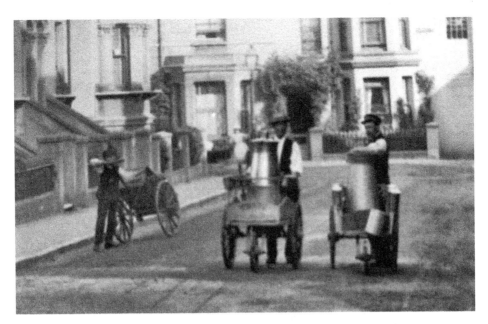

York Road, c. 1890
York Road, which runs into Grove Road, was designed for residents who were financially comfortable. It is noticeable, however, that (like other people in Eastbourne) they were receiving their milk ladled out from churns. There was no real control on the milk's quality. It almost certainly had neither been pasteurised nor collected from tuberculin-tested cows. Furthermore, there was always a temptation for milkmen to water the milk. (*ECL*)

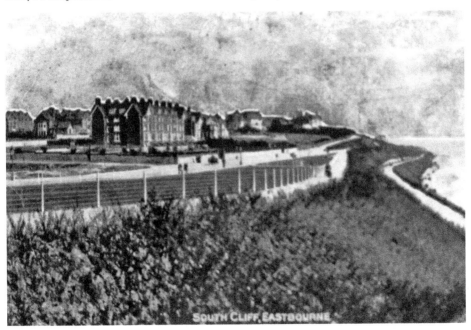

King Edward's Parade, Postcard Sent 1905
By the turn of the twentieth century, the westward extension of Grand Parade was well developed. After Edward VII visited the town in 1903, it became known as King Edward's Parade. (*ECL*)

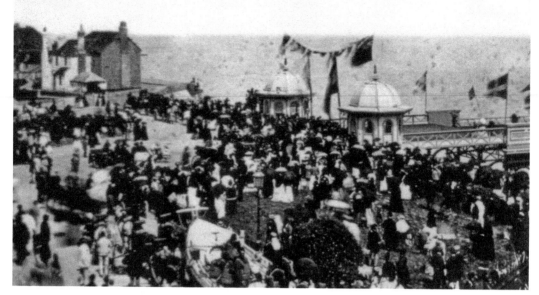

Opening the Pier, 1870
By the late nineteenth century, it was axiomatic that a major seaside resort would sport a pier. The pier at Eastbourne (or rather the landward part of it) was opened by Lord Edward Cavendish, a son of the Duke of Devonshire. (*ECL*)

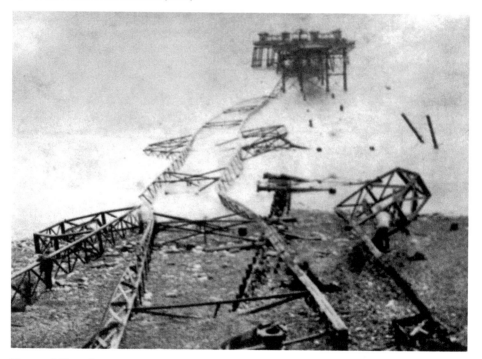

Damaged Pier, 1877
The new pier had evident faults in its construction, and it was severely damaged by a great storm in 1877. It was soon restored, but there were some changes at the landward end. (*ECL*)

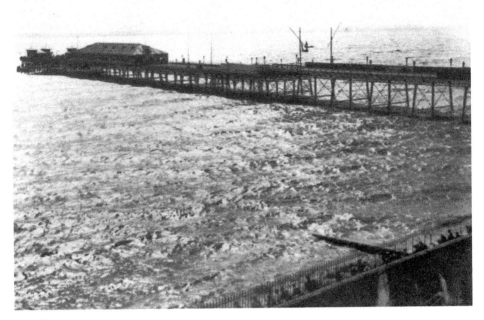

Pier Theatre, c. 1899
In the closing years of the nineteenth century, seaside piers developed from places for casual and elegant perambulation to places of entertainment, complete with slot machines and kiosks. In Eastbourne, a theatre was built at the end of the pier. It should be noted that the landward part of the pier was at a slightly different level from the seaward part, a change which was found necessary when the storm damage of 1877 was repaired. (*ECL*)

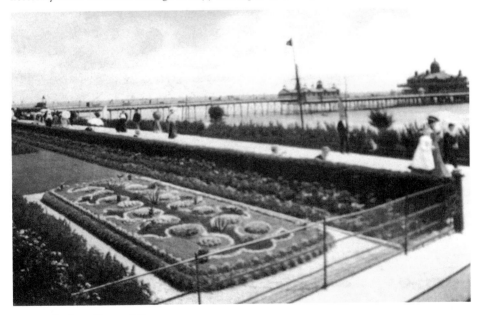

Carpet Gardens. Postcard Sent 1907
As early as the 1870s, the attractive Carpet Gardens were set out along the seafront. This postcard, over 100 years old, brings out their gorgeous colour. (*ECL*)

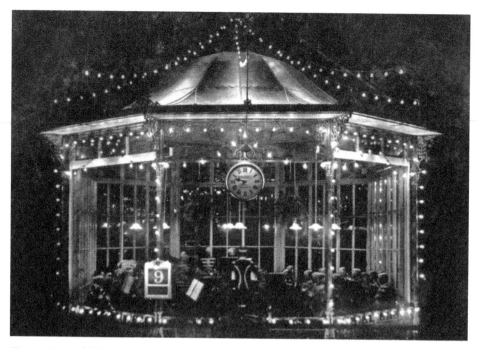

Western Central 'Birdcage' at Night, *c.* 1900
Just as necessary as a pier to a traditional seaside resort, was a bandstand. This photograph shows the old 'birdcage' bandstand at night. The electric light illuminations were another recent feature in the late nineteenth century. For many years to come, electric lighting was by no means universal, even in houses in towns. (*ECL*)

Developments in the Meads, in the 1880s
The Meads area in the west of Eastbourne was developed rather later than the seafront. In this photograph, development is in progress. All Saints church, Carlisle Road, may be seen on the right. (Lawrence Stevens, *A Short History of Eastbourne*, Eastbourne Local History Society, 1987)

4

Life in New Eastbourne:

The Serious Side

The great building and associated development that took place in Eastbourne from the 1850s onwards necessarily brought a huge influx of people: a great many new residents and (particularly in the summer) enormous numbers of visitors. Much was needed to satisfy the requirements of those people. Some of this was performed on a fairly small scale. There were new hotels, boarding houses and retail outlets, for example, but other changes were a good deal more extensive.

Before the great development of Eastbourne in the second part of the nineteenth century, the single parish church of St Mary's and one or two Nonconformist chapels sufficed for the religious needs of Eastbourne. Nearly everybody lived within a mile or so of the church, while the journey home could doubtless be fortified by a visit to one of the nearby inns. The late nineteenth century was a period when religious faith and observance were strong, and a feature of the town which strikes the visitor today, is the considerable number of quite large late nineteenth century churches, of various denominations, which had been built in developing parts of Eastbourne. Some appear to have been built, as much to impress visitors, as to discharge their ostensible purpose. Not only was there deep religious feeling, but there was also sufficient local money to create these buildings, in the full anticipation that they would attract substantial congregations.

Eastbourne's growing size and importance was soon reflected in advanced municipal dignity. It was constituted a borough in 1883, and a few years later acquired its present town hall. The redistribution of parliamentary seats in 1885 resulted in the establishment of the new constituency of Eastbourne, alternatively known as South Sussex. The Eastbourne constituency extended (it still does extend) some distance from the town.

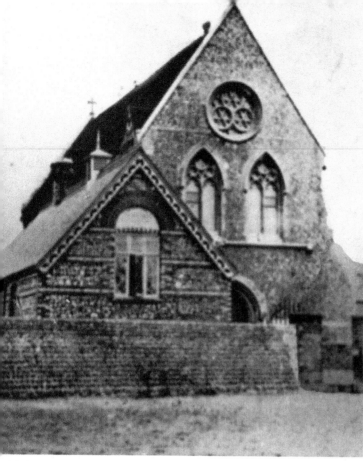

Right: **Christ Church (Church of England), Seaside, 1870s**
One of the early new churches was Christ church. This was built to serve the general area of Sea Houses, a part of Eastbourne with a growing population which was located some distance from the Old Town. (*ECL*)

Below: **All Souls Church (Church of England), Susans Road, Late Nineteenth Century**
From an architectural point of view, one of the most remarkable churches in Eastbourne is All Souls, on Susans Road, built in the Lombardy-Byzantine style. The cost of construction of the church, the associated church rooms and a vicarage building was defrayed by Lady Victoria Pole-Tylney-Long-Wellesley, great-niece of the first Duke of Wellington. (*ECL*)

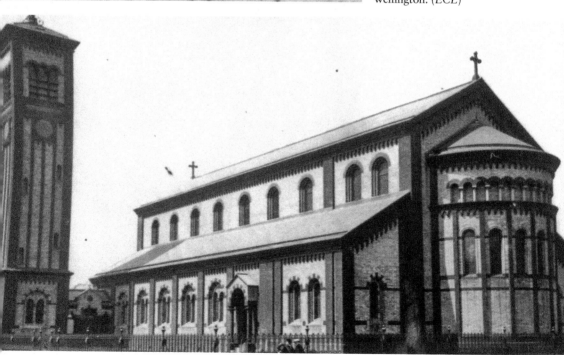

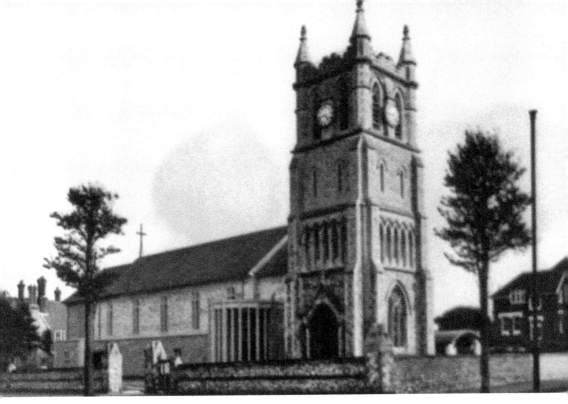

Above: St John the Evangelist (Church of England), Meads
St John the Evangelist at Meads (another early Eastbourne church) was consecrated in 1869, evidently in anticipation of the future development of that part of Eastbourne. The photograph shows the original church, which was bombed in 1942, but has since been rebuilt. *(ECL)*

Right: Central Methodist Chapel, Pevensey Road
Most of the traditional residents of Eastbourne probably adhered to the Church of England, but incomers to the town included a substantial number of Nonconformists of various denominations. A Wesleyan chapel in Grove Road may originally have been related to the requirements of soldiers, who arrived during the French wars at the turn of the eighteenth and nineteenth centuries. As time went on, the old Wesleyan chapel proved inadequate for Nonconformist demand, and a new Methodist chapel was built. In this period, a distinction was often drawn between Primitive Methodists and Wesleyans, which sometimes had social and political overtones. In the twentieth century, the two bodies united. *(ECL)*

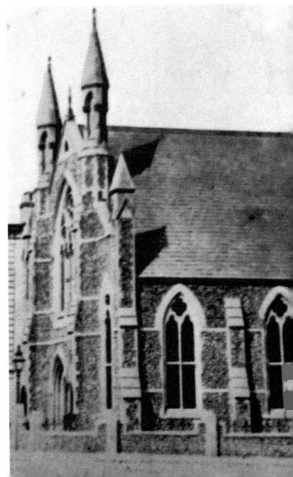

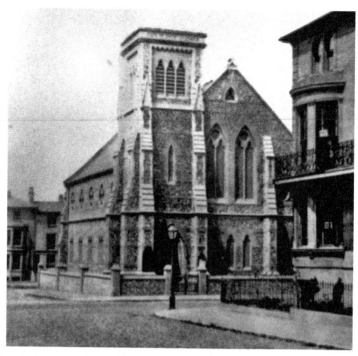

Congregational Church, Cavendish Place
Another early Nonconformist development was this Congregationalist church, opened in 1863, which was demolished in 1973.(*ECL*)

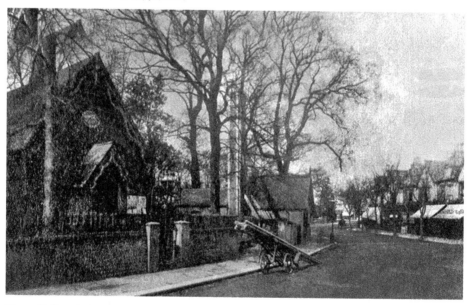

Vestry Hall and Fire Station
Before Eastbourne attained full municipal status, the administrative centre was the Vestry Hall, located in Grove Road. More than one structure has sometimes been described as the Vestry Hall, but the larger building to the left of this photograph appears to be the correct one. The building to the right of centre was probably the fire station.

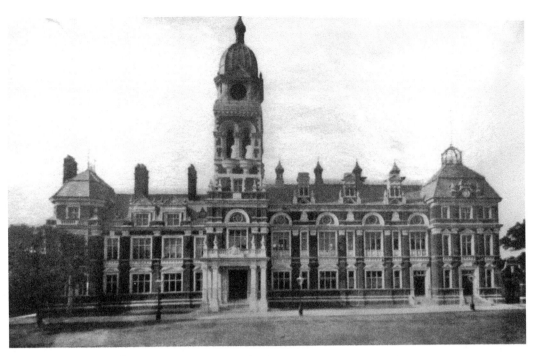

Above: Town Hall, *c.* 1886
The incorporation of Eastbourne as a borough led to the establishment of a town hall. The foundation stone of this impressive building in Grove Road was laid in 1884. The appearance of the town hall has not changed greatly since then, but the immediate environment is now different. (*ECL*)

Right: New Drains, 1898
As Eastbourne expanded, facilities were extended as well. These new drains were constructed at the close of the nineteenth century, in the vicinity of what is now Prince's Park. (*ECL*)

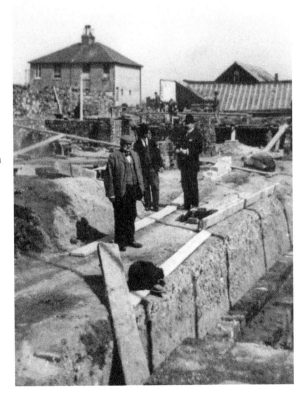

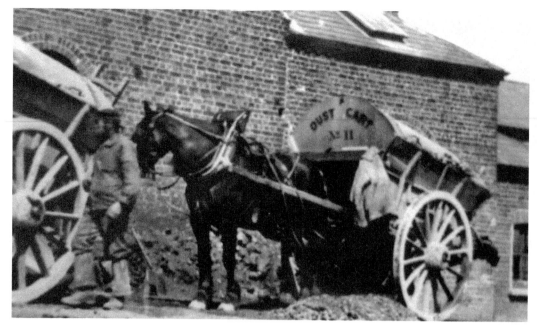

Dust-Cart, 1898
Refuse disposal in the late nineteenth century was still primitive by modern standards. This horse-drawn dustcart dates from the same year as the previous photograph. (*ECL*)

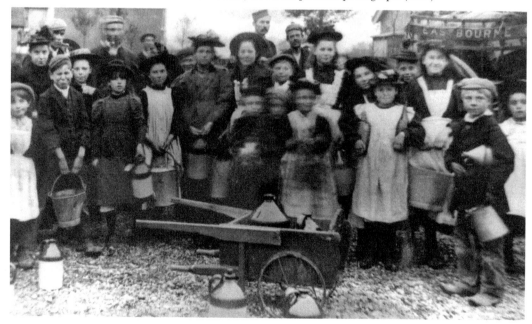

Water Carriers at the Archery, 1896–97
Occasionally, utility supplies broke down. By August 1896, the waterworks at Bedfordwell, not far from the Old Town, had been abandoned. The waterworks at Friston, several miles away, would not be ready until March 1897. In the meantime, drinking water was supplied by standpipes. (*ECL*)

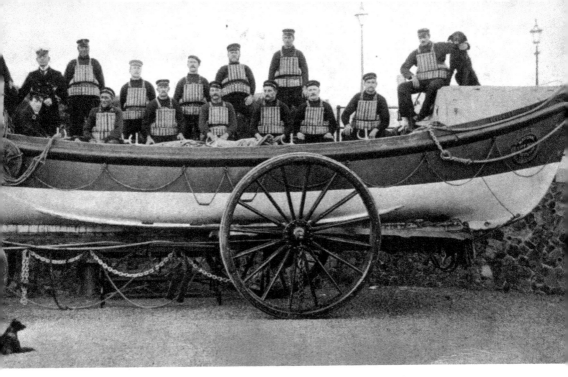

Eastbourne Lifeboat and Crew, 1899
The dangerous character of the coast near Beachy Head necessitated the establishment of a good lifeboat service. Fortunately there were sufficient men brave and skilled enough to undertake this hazardous work. (*ECL*)

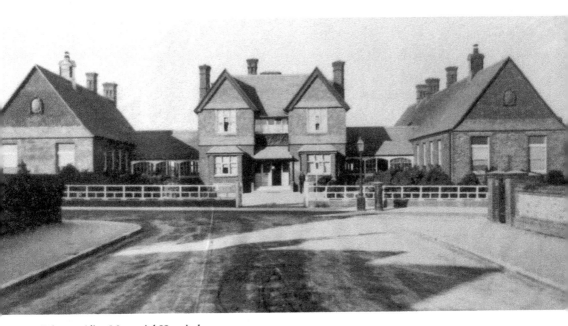

Princess Alice Memorial Hospital

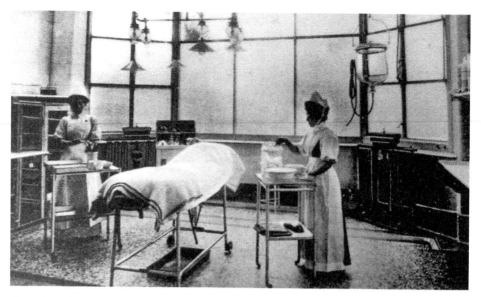

Operating Theatre, Princess Alice Memorial Hospital. Postcard From Before 1920
Princess Alice was a daughter of Queen Victoria who had paid a visit to Eastbourne not long before her death. A tree, which she planted on that occasion, remained in the town until it was replaced by the War Memorial in 1920. She was keenly interested in nursing, and did much hospital work in the Franco-Prussian war of 1870/71. She later founded the Women's Union for Nursing the Sick and Wounded in War. By tragic coincidence, her death in 1878 was occasioned by diphtheria contracted while nursing her husband and children. The hospital in Eastbourne which bore her name was opened in the 1880s, but closed in 1996/97. (*ECL*)

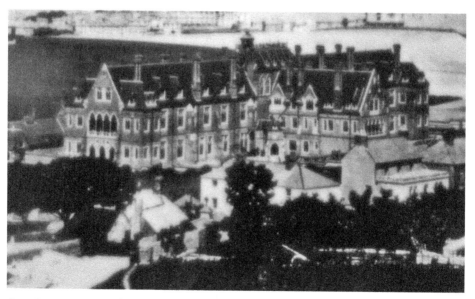

Convalescent Home (All Saints Hospital)
In earlier times, recovery from operations or illness necessitated long periods of convalescence under professional supervision, much more frequently than is the case today. All Saints Hospital, opened in 1869, was an early and substantial example of convalescent care in Eastbourne. (*ECL*)

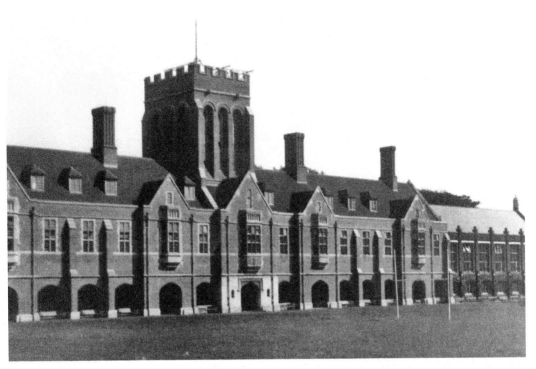

Above: Eastbourne College, *c.* 1930
As Eastbourne grew, several new foundations were set up as private schools. The biggest of these was a boys' school, Eastbourne College. It was originally operated in Spencer Road, but the building familiar today was completed in 1877. (*ECL*)

Right: South Lynn Girls' School, Mill Gap Road, 1931
This was another early private school, established in 1886 in the Upperton area. It was demolished in 1931. Most of Eastbourne is too new to be concerned with the possibility of ghosts, but South Lynn School was reputed to be haunted. (*ECL*)

5

Life in New Eastbourne:

Leisure

In the history of Eastbourne, the second half of the nineteenth century might be considered the 'reign' of the 7th and 8th Dukes of Devonshire. Both men showed a real interest in the town's development, which went well beyond their obvious financial concern. In early days, the ducal interest played a large and demonstrable part in the leisure activities of the town, but by the end of the century these activities had acquired a momentum of their own. In this chapter, we will trace something of the link in the leisure lives of residents and visitors.

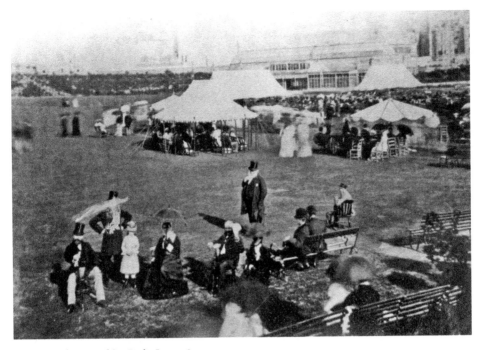

Opening of Devonshire Park, June 1874
In the early development of Eastbourne, much attention was given to other amenities as well as buildings and public utilities. An early example was Devonshire Park, adjacent to the modern Congress Theatre, which was opened in 1874. (ECL)

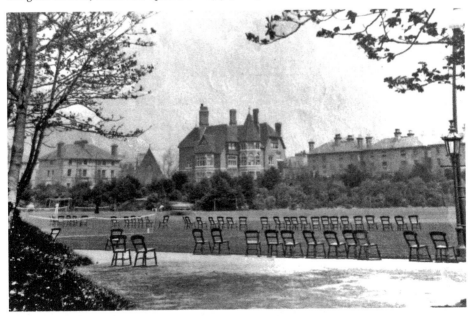

Devonshire Park, at the Turn of the Twentieth Century
The late nineteenth century saw the development of public parks in most substantial towns, and much of Eastbourne's Devonshire Park was simply a place for quiet relaxation, as the seats on the grass suggest. (ECL)

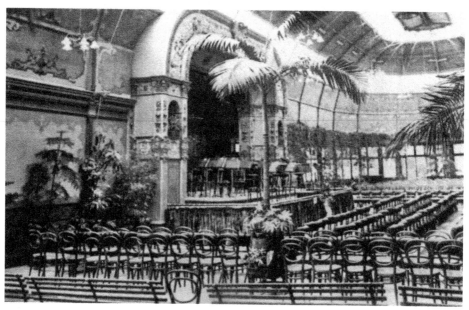

Devonshire Park Concert Room, at the Turn of the Twentieth Century
Devonshire Park rapidly became a centre for many kinds of activity. This photograph shows the interior of a hall, which soon became an important centre for musical entertainment. (*ECL*)

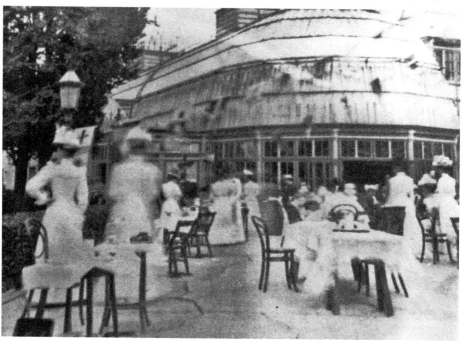

Winter Gardens Terrace, *c.* 1900
The idea of creating 'Winter Gardens', where exotic and tender plants could be enjoyed at all times of the year, was encouraged by the Cavendish family. People familiar with Buxton will note a considerable similarity of design, with similar facilities in another town where the Devonshire influence was strong. (*ECL*)

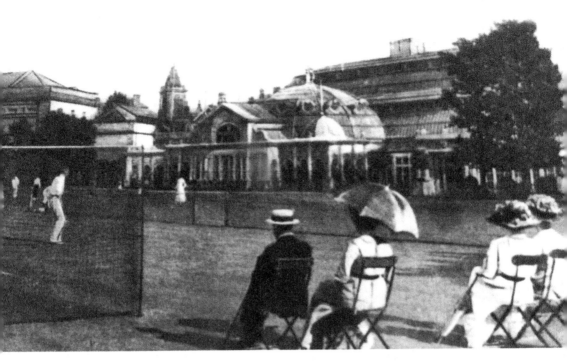

Above: Devonshire Park Lawn Tennis
Ground, *c.* 1900
Enthusiasts for tennis (more strictly
lawn tennis) will be familiar with the
association between the sport and
Eastbourne, which began in the late
nineteenth century. (*ECL*)

Right: Devonshire Baths,
Late Nineteenth Century
Indoor swimming baths were becoming
popular in the late nineteenth century.
The Devonshire Baths at Eastbourne
(which were saltwater) were opened
in 1874, but closed in the 1990s
when better facilities became available
elsewhere in the town. (*ECL*)

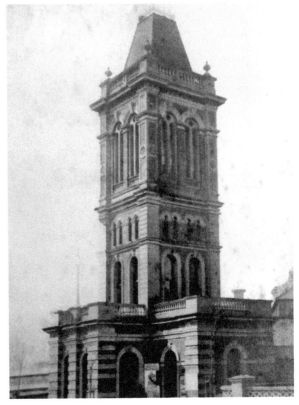

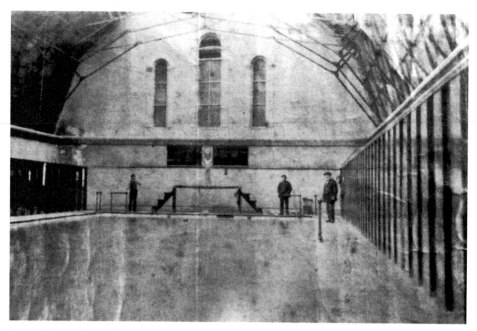

Devonshire Baths: Inside View
The interior of the nineteenth-century Devonshire Baths looks rather old-fashioned today, but public swimming baths were still something of a novelty when they were built. Changing cubicles led directly to the baths surround. (*ECL*)

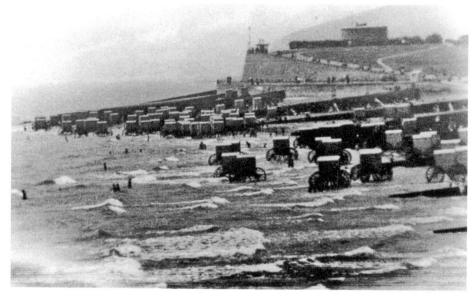

Bathing Machines Near the Wish Tower, Late Nineteenth Century
Sea bathing was becoming popular in the late nineteenth centry, but propriety required bathers to change clothes in these little wheeled carts. Years would pass before daring souls began to change in their hotel rooms, don outer clothing and slip down to the beach where they removed that outer clothing and entered the water. Eventually people became more daring still, and actually changed on the beach.

Right: Local Boat Trips, 1895
'Any more for the Skylark?' By
the late nineteenth century, many
of the entertainments available at
Eastbourne today were already in
place. Short boat trips were already
popular, but most of the pleasure
boats were not yet mechanically
powered. (*ECL*)

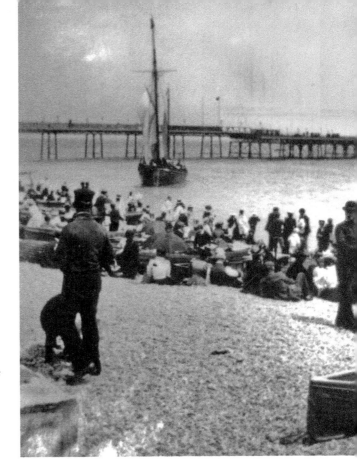

Below: Royal Eastbourne Golf
House, Before Removal to the New
Site in 1904
Golf was becoming a popular sport
in many parts of England in the late
nineteenth century, although it did
not acquire the 'classless' character
which it possessed in Scotland. The
Royal Eastbourne Golf Club was
established in the 1880s. (*ECL*)

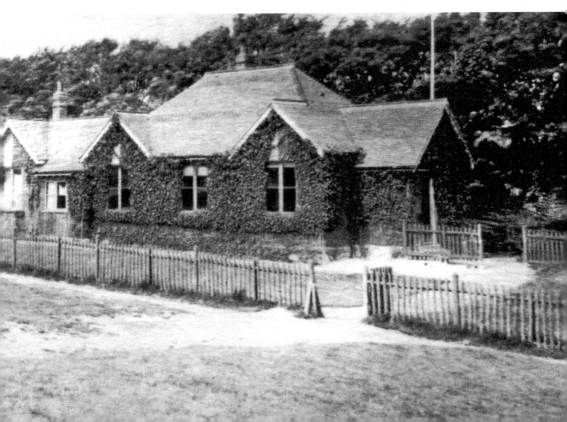

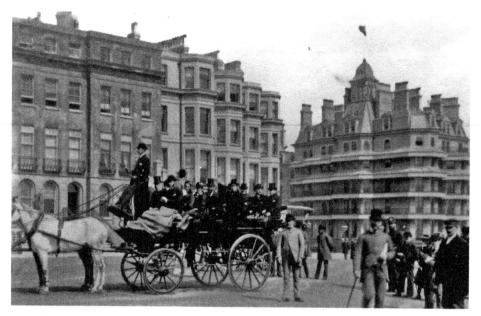

Horse Transport in Eastbourne

In the late nineteenth century, horse-drawn public vehicles that might be described as buses, were operating in Eastbourne. The dress of the passengers and the open character of the vehicle, illustrated here, suggests that this one was designed to give moderately affluent people short pleasure trips in the holiday season. (*ECL*)

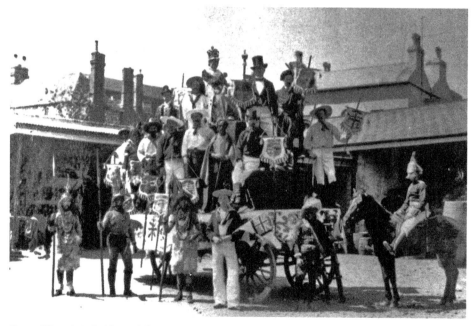

Queen Victoria's Golden Jubilee, 1887

The fiftieth anniversary of Queen Victoria's accession was celebrated with much enthusiasm throughout the country. This Eastbourne float apparently represented an idealised view of the British Empire, with an even more idealised representation of the Queen herself at the apex. (*ECL*)

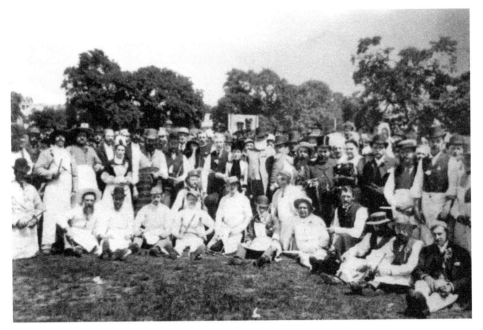

Golden Jubilee, Group Photograph, 1887
As Victoria had become Queen in June 1837, the fiftieth anniversary of her accession fell conveniently on a dry day in early summer. Eastbourne residents, with perhaps a sprinkling of visitors, were able to pose comfortably on the grass to celebrate the occasion. *(ECL)*

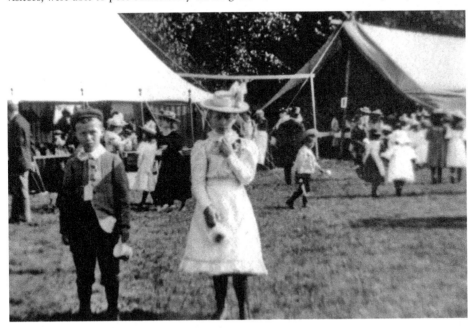

Queen Victoria's Diamond Jubilee, 1897
Ten years later, Victoria's Diamond Jubilee was the reasoning for further celebrations. These Eastbourne festivities took place on South Fields, not far from the Old Town. As with the earlier Jubilee, Eastbourne was favoured with good weather for the occasion. *(ECL)*

6

Into a New Century

By the end of the nineteenth century, much of the physical structure of the main part of modern Eastbourne had already taken shape. However, in other places, Eastbourne was a very different place from the modern town. A great deal of development would soon take place at the edges of the existing built-up area, and further facilities would become available for public enjoyment. More important still, life would soon change dramatically for the town's inhabitants.

Transport, in particular, would undergo great changes. In 1900, the internal combustion engine had existed for a number of years, and there were a few cars running. However, these cars were essentially toys for rich men. The large majority of people, even wealthy people, did not own motor vehicles, and felt no urgent wish to do so, for they were not only very expensive but also uncomfortable and unreliable. Nearly all transport was still powered by the horse or by the steam engine.

The year 1903 witnessed two enormous leaps forward in the use of the internal combustion engine. One is very well known; the first powered flight by people using a heavier-than-air machine, conducted by the Wright brothers in the United States. The other, far less famous but no less portentous for the future, derives from Eastbourne. The first use of the internal combustion engine in a machine that was available to ordinary humans of moderate means occured through the inauguration of a system of municipal, petrol-driven buses.

In the second decade of the new century, Eastbourne would play a significant part in the early development of the aeroplane. A good many changes would also take place in other aspects of human life, so that by the outbreak of war in 1914, Eastbourne had changed considerably from the town of the late nineteenth century.

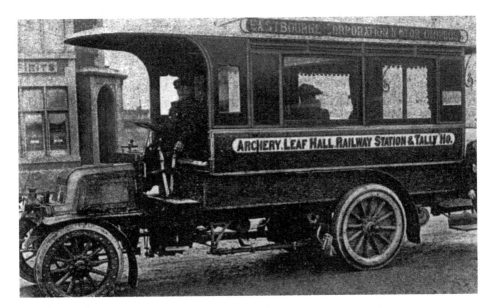

One of the First Municipal Buses
Other towns had already used electric trams, and Eastbourne had already experimented with steam buses. Eastbourne, however, established what may have been a world first (definitely a British first) with its municipally owned and operated motor buses in 1903. (*Eastbourne Borough Motor Buses: The First 80 Years*, Southdown Enthusiasts Club, 1983)

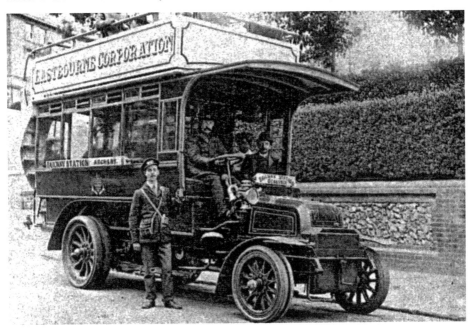

An Early Double-Decker Bus, *c.* 1904
Just a year after the first single-decker, municipal petrol buses took to the roads in Eastbourne, double-decker machines appeared. Journeys must sometimes have been very uncomfortable, for the buses had solid tyres and the upper deck was not protected from wind, rain, cold and snow. (*Eastbourne Borough Motor Buses: The First 80 Years*, Southdown Enthusiasts Club, 1983)

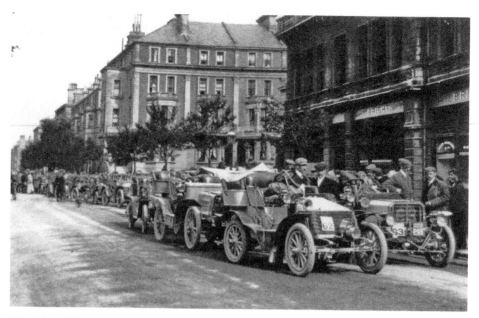

First Meet of Motor Cars, Compton Street, 1902
The petrol-driven internal combustion engine was widely used for public transport, well before it came into general use for private purposes. The cars present at this early meet probably represented a high proportion of those actually in existence, within reasonable access of Eastbourne. (*ECL*)

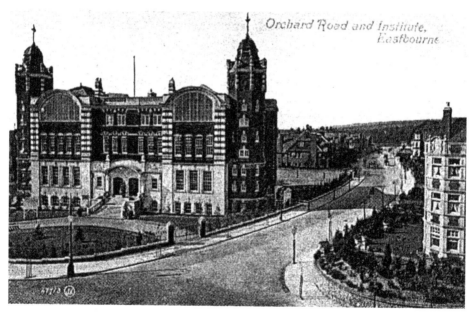

Eastbourne Technical Institute, *c.* 1904
Eastbourne's first public library was opened in 1896. The foundation stone of a much larger building, at the corner of Grove Road and (Old) Orchard Road was laid in 1903. This was designed to serve as the public library, technical institute, museum and school of art. The building would be destroyed in the Second World War. (*Eastbourne Local Historian*, 150, Winter 2008)

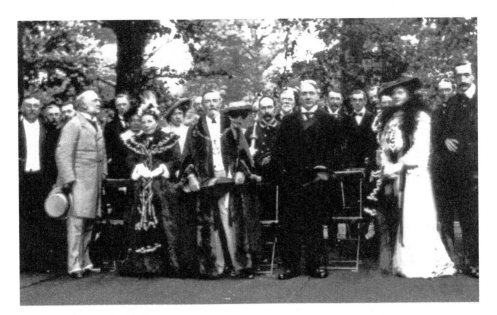

Opening of Hampden Park, 1902
At the date of this photograph, the Hampden Park area was included in Willingdon, although it would be transferred to Eastbourne a decade or so later. The park itself, which had been part of Lord Willingdon's Ratton estate, was acquired by the local authority at the turn of the century. The Earl of Rosebery (with wing collar, a little to the right of the centre of the photograph) was a former prime minister and foreign secretary, and is shown at the opening ceremony. Like some other major politicians of the period (including the 8th Duke of Devonshire, former Marquis of Hartington), Rosebery was keenly interested in local government. He had served for a time as chairman of the London County Council. Hampden Park was, and is, an amenity much used by local residents. (*ECL*)

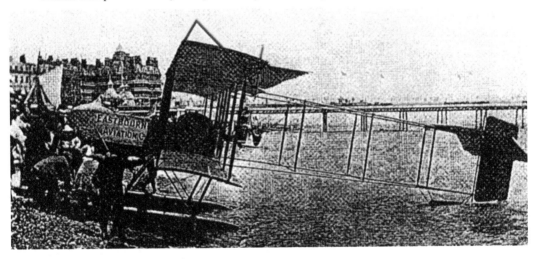

Eastbourne Aviation, *c.* 1912/13
The first Channel flight, by Louis Blériot in 1909, gave considerable impetus to the idea of flying in heavier-than-air machines. A local aviation pioneer, Frederick Fowler, first taught himself to fly and then instructed others. This photograph shows a Blériot-type aircraft promoted by the Eastbourne Aviation Co., which Fowler established, and which commenced its own production of aircraft in 1913. (Michael Partridge, 'The Centenary of Aviation in Eastbourne', *Eastbourne Local Historian*, 162, 2011)

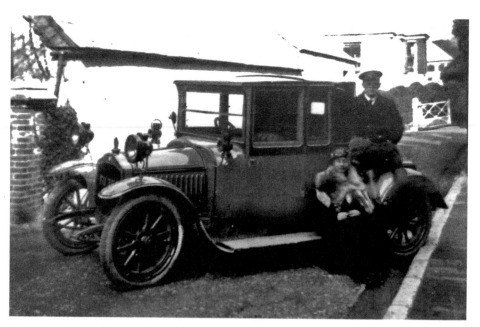

Frederick and Josephine Fowler, With a Wedding Present, 1913
The Eastbourne aviation pioneer Frederick Fowler married in 1913, and the couple received a De Dion Bouton car as a wedding present from the bride's family. The car contrasts with the vehicles that congregated at the Eastbourne meet, eleven years earlier, and was sufficiently reliable for the couple to spend their honeymoon touring in. (*ECL*)

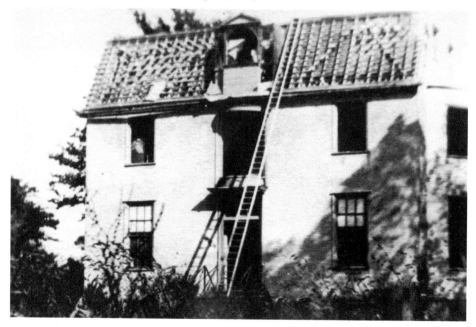

Demolishing The Grove, c. 1902
The end of The Grove marked a significant point in the development of Eastbourne. After its early period as a private house, it became a preparatory school, whose proprietors were not universally liked – 'mean ol' devils' was one judgement. It soon made room for shops. (*ECL*)

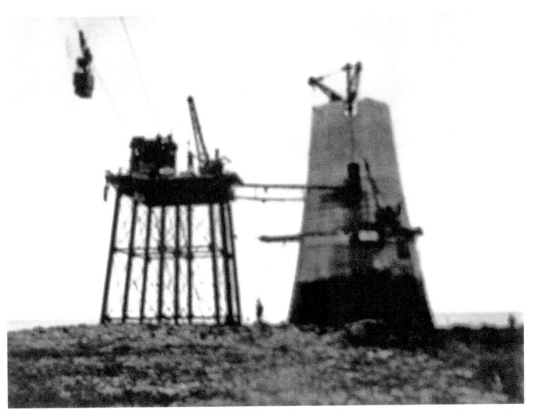

Above: **Building a Lighthouse, 27 September 1901**
The old Belle Tout lighthouse, on top of Beachy
Head, was not ideally located. The construction
of a new one, out at sea from the dangerous
promontory, was undertaken at the beginning of
the new century. This photograph shows a stage
in the operation. To the top left, construction
material is being carried down from the cliff
top. (*ECL*)

Right: **Beachy Head Lighthouse and
Devil's Chimney**
The new lighthouse was soon functional and
superseded the old Belle Tout lighthouse. The
chalk stack nearby, known as Devil's Chimney,
eventually collapsed as the sea gradually
encroached. (*ECL*)

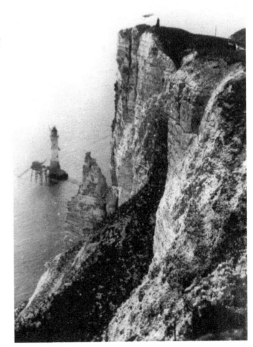

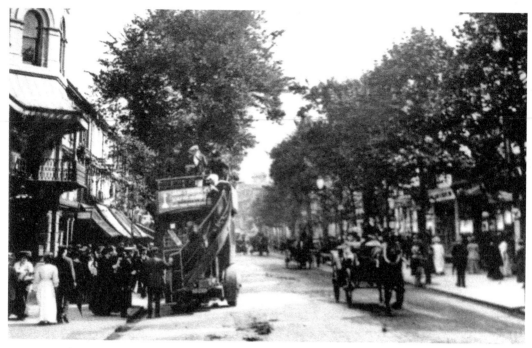

Terminus Road, 1908
The transition from horse-drawn to motor-driven transport was uneven. This postcard of Terminus Road brings this point out. Eastbourne was well ahead with its motor buses (they did not appear in London until 1909) but most other kinds of transport were still horse-driven, and some kinds of traders' vehicles remained so until well after the Second World War. (*ECL*)

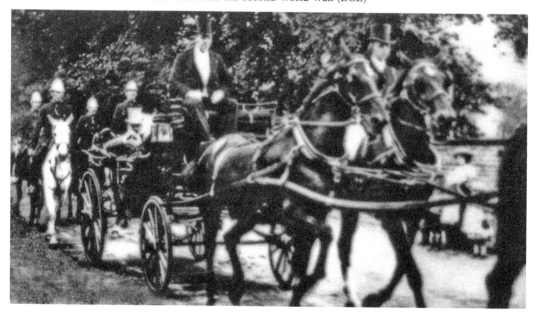

Royal Visit to Eastbourne, July 1903
The first recorded visit to Eastbourne by a reigning sovereign was paid by Edward VII in 1903. As we have noted, the name of King Edward's Parade celebrates the occasion. (*ECL*)

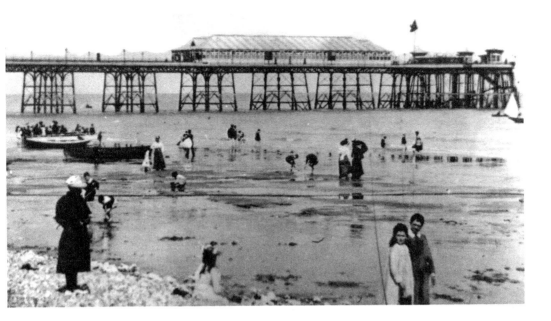

Above: **Eastbourne Seafront, *c.* 1903**
A beach scene at low tide, from early
in the twentieth century, shows much
that is modern; the paddlers, the pier,
the excursion boat. But there are
also very dated features, notably the
clothing of the holidaymakers. Unless
they were actually swimming, people
dressed for the beach more or less
as they would dress if they were in
an inland town. The women's skirts
were very long, and must have proved
a considerable nuisance when they
ventured to paddle. (*ECL*)

Right: **Colonnade, Seaside Road,
c. 1915**
Even in urban Eastbourne, the horse
remained the principal source of power
for vehicles into the second decade of
the twentieth century. There were petrol
buses and a very few cars on the roads,
but nearly all other vehicles still relied
on animal power. (*ECL*)

7

The Great War and After

The First World War had a huge impact on peoples' lives in Eastbourne, for approximately one in fifty of the town's population perished. A great many suffered serious injury, and almost every family lost members or close friends. There was massive disruption of ordinary existence in the later stages of the conflict, including serious shortages of food and other essentials, and the imposition of unfamiliar new regulations, such as rationing, which controlled supplies. There was some development of war industries; notably aviation. Yet the effect on the fabric of Eastbourne was slight. A number of English towns were bombarded either by sea or by air, but Eastbourne was not among them.

When the war ended, some features of Eastbourne soon reverted to their pre-war condition. The town did not suffer as severely as many others, either from the short, sharp recession of 1921, or from the deeper and more prolonged depression of the early 1930s.

Many changes of the inter-war period were positive from Eastbourne's point of view. More and more people in southern England were able to afford a week or fortnights annual holiday. Visits abroad were still outside the sights of the majority of British people, but a stay in a coastal town like Eastbourne was a realistic prospect. Hotels and boarding houses developed. Cheap day trips from London or other places in the southeast were available by train and, increasingly, by coach (or, as people usually called it in those days, charabanc). Electrification of overground railways was developed much sooner in places south of the Thames than in most other parts of the country. In 1935, the railway from London to Eastbourne was electrified and the first of the new trains arrived. Private road travel, first by motorbike and soon by car, became increasingly common.

More dwelling and boarding houses were built. The most obvious change, noticed by the casual visitor, was the much bigger bandstand with abundant undercover seating that appeared in the 1930s. Like other seaside towns, Eastbourne had a relatively short and intensive tourist season in the warmer part of the year, and a certain amount of light industry to sustain people who remained there during the winter.

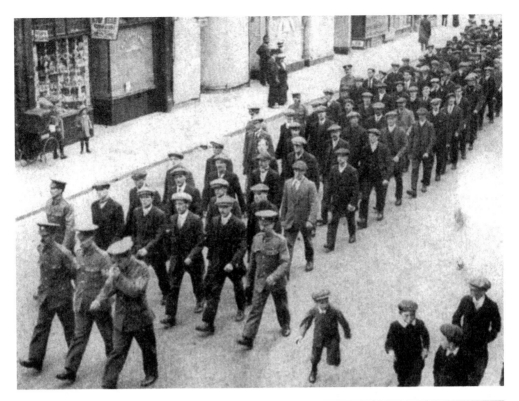

Above: New Recruits Marching Down Seaside Towards Ordnance Yard, *c.* 1914

When war came in 1914, Britain, unlike many continental countries, did not have conscription. Lord Kitchener, the new Secretary for War, raised an immediate call for volunteers and the response was enormous, as this photograph shows. Although the men were still in civilian clothes, their suits were remarkably uniform. Nearly all of them were wearing caps, and so too, were the boys accompanying the march. People of all ages and both sexes still assumed that headgear was essential. (*EHS*)

Right: Comic Leaflet, 1915/16

Light is sometimes cast on serious events by humorous publications. This leaflet refers to Lord Kitchener's original volunteer army (sometimes nicknamed the 'Old Contemptibles') which was raised immediately after the outbreak of war in 1914. Some months later, when people began to realise what war was really like, voluntary recruitment began to dry up, and in 1915 'Lord Derby's Scheme' was invented to put all pressure, short of compulsion, on men who had not enlisted. This leaflet was produced at that time. In 1916, conscription was introduced; first for unmarried men and eventually for married men as well. (*Postcard, courtesy of Eastbourne Museum of Shops and Social History*)

URGENT!

Thousands of Nice Young men are Wanted in EASTBOURNE.

Over 8000 Girls are sighing for what they cannot get—Husbands. Shame !

Don't hesitate—Come at Once.

If you cannot come send your brothers.

SO GREAT IS THE DEMAND THAT ANYTHING WITH TROUSERS STANDS A CHANCE.

EXTRA SPECIAL :
KILTS NOT OBJECTED TO.

KITCHENER'S ARMY IN DEMAND.
DERBY RECRUITS DON'T BE SHY.

No Reasonable Offer Refused.

They are shy, but willing.
All Prizes—No Blanks.
There are Icy Girls and Spicy Girls.

FREQUENT EXCURSIONS.

Special Application card from

Medical Officer reports that there are over 8,000 more Females than Males in Eastbourne.

COPYRIGHT.

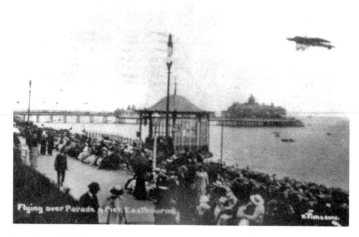

'Flying over Parade and Pier'

During the First World War, the Eastbourne Aerodrome was of considerable importance in the fight against enemy submarines, and for a time, Frederick Fowler was the commanding officer there. At an early stage of the war, it came under control of the Royal Naval Air Service, and was extensively used for observation. This postcard, sent in 1917, throws significant light on the different impact of the two world wars on Eastbourne. The aircraft, though considerably more advanced than anything which had existed a few years earlier, was much less so than those employed in the later war. Many holidaymakers were present on the promenade, for there was no serious fear of enemy invasion and it was not necessary to restrict access to promenades and beaches. In some ways, the conflict was 'total war', but in other matters it seemed to be 'business as usual'. (*ECL*)

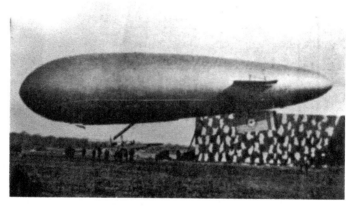

BE2C-Type Airship at Polegate, 1918

Until the 1930s, it was by no means clear if the future belonged to heavier-than-air aeroplanes or to gas-filled airships; whether for peaceful or warlike purposes. Both were used in the First World War. In some ways, airships seemed to have the advantage for they could carry much heavier loads than the aeroplanes of the time, and could remain away from base for longer. The particular disadvantage of airships was that they were filled with highly-inflammable hydrogen (though non-inflammable helium was sometimes used later). In the First World War, airships as well as aeroplanes were used in watching for enemy U-boats. Early in the war, an airship station was established near the Polegate–Willingdon boundary. After considerable early difficulties, it became remarkably efficient, and the commodore of the Air Services considered it 'the smartest, cleanest and most efficient' of the air stations he had inspected. (*ETH*)

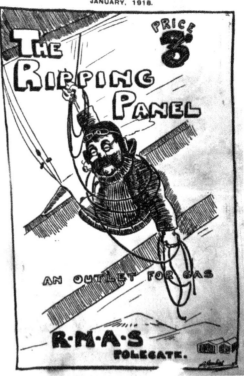

Right: 'The Ripping Panel', January 1918
Workers involved in the construction, testing
and use of airships at Polegate produced a
light-hearted magazine. (*ECL*)

Below: Wrecks of SS *Oushia* and a German
submarine, *Birling Gap*
The war at sea was very noticeable in the
Eastbourne area during the First World
War. The dangers associated with the cliffs
near Beachy Head were even more dire than
in peacetime. In this dramatic photograph,
the wrecks of a British merchant ship and a
German submarine were brought
together. (*ECL*)

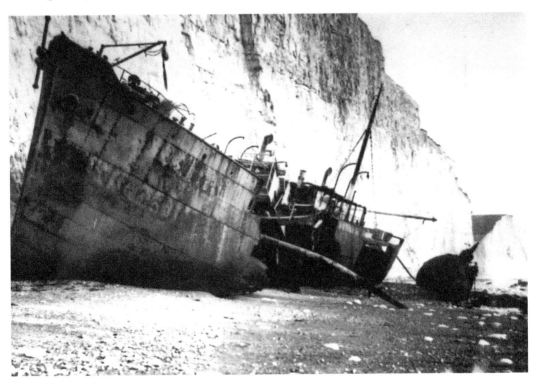

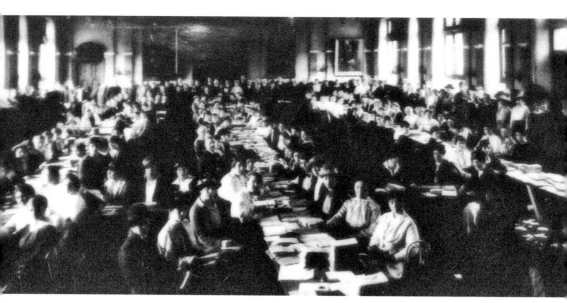

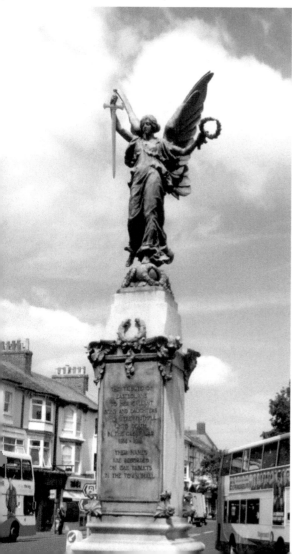

Above: **Food Controllers, Eastbourne Town Hall**
As the First World War developed, the threat posed to British food supplies by German submarines became increasingly evident. Supplies had to be controlled, and later rationed. This necessitated the employment of a considerable number of administrators. (*ECL*)

Left: **Eastbourne War Memorial**
Eastbourne's war dead, more than 1,000 men and women, were far too numerous to be recorded on the town's memorial. Instead, the names are inscribed on oak tablets stored at the town hall. To that sad list should be added an indeterminate number of people whose lives were blighted or shortened by injuries sustained, and an even greater number of relatives and friends who grieved.

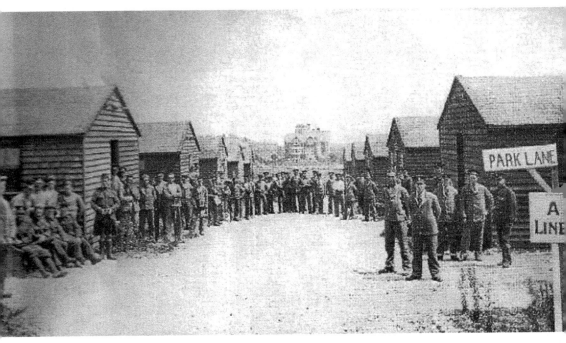

Summerdown Camp

A huge convalescent hospital for soldiers injured or sick in the First World War was established at Summerdown, not far from the Old Town. The 'Muster Parade' photograph shows beneficiaries numbered in their many hundreds. No doubt this experience introduced many people to Eastbourne who had not known it before, and some at least, later returned with their families as holidaymakers. (Summerdown Military Convalescent Hospital, *c.* 1918)

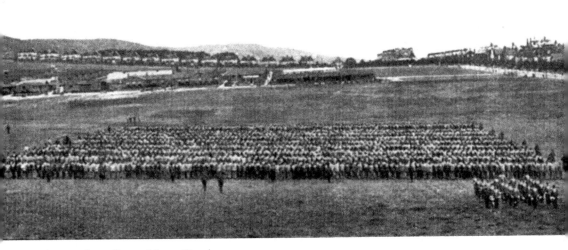

Summerdown Camp, Muster Parade

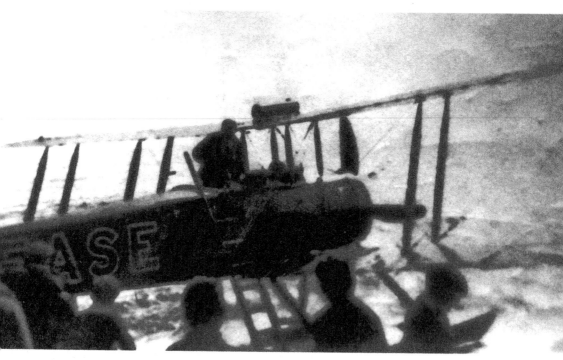

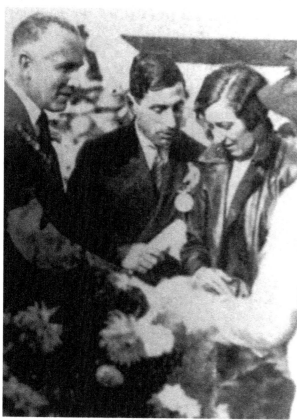

Above: Seaplane at Eastbourne, 1920
By the early 1920, pleasure flights were available at Eastbourne. Prices were considerable in terms of value at the time, but they were probably just affordable as rare treats for people of modest means. Most of the flights were in ordinary aeroplanes; some, at a rather higher price, were in seaplanes, which had been specially adapted for landing on water. (*ECL*)

Left: Amy Johnson Greeted by Mayor Sir Roland Gwynne, on arrival at King's Drive Aerodrome, Eastbourne, August 1930
One link between Eastbourne and aviation was vicarious rather than direct. Earlier in 1930, the young Amy Johnson attracted huge national attention as the first woman to fly solo from Britain to Australia. Her visit to Eastbourne a few months later, with the biplane 'Jason' in which she made the epic flight, was an occasion of much local pride. (*ETH*)

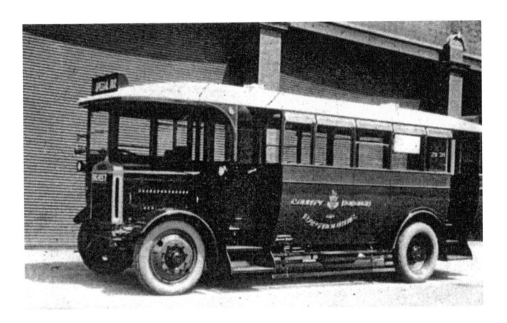

Eastbourne Corporation Bus, 1928 Model
By the late 1920s, some of the single-deck Eastbourne buses had taken on an almost modern appearance. (*Eastbourne Borough Motor Buses: The First 80 Years*, Southdown Enthusiasts Club, 1983)

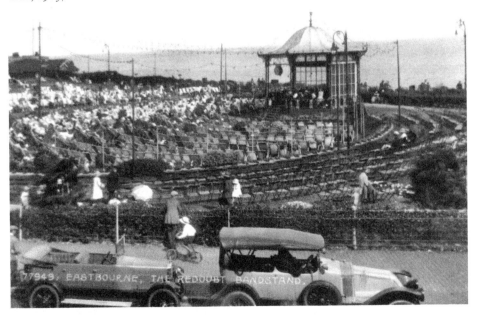

Redoubt Bandstand, Postcard from 1925
The eastern end of the seafront was increasingly developed for tourism, and a bandstand at the Redoubt attracted considerable attention. Motor cars were becoming more widely available, although they were still too expensive for most people. The car visible in the foreground was obviously designed for pleasure trips in good weather, with some protection in case of rain, rather than for all-season use. (*ECL*)

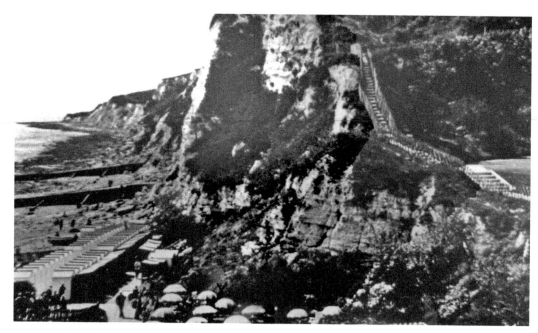

Holywell Retreat, 1931

The western end of Eastbourne was also still being developed for tourists in the inter-war period. Bathing chalets, where people could sit and relax as well as change for swimming, had replaced the old bathing machines. There was already a café at Holywell. (*ETH*)

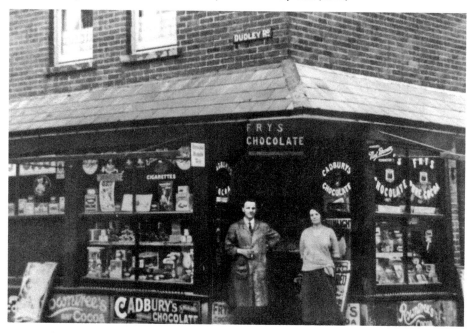

Corner of Dudley Road, 1923

Throughout the inter-war period, the usual retail outlet was still the corner shop. This one offered the products of three different manufacturers of cocoa and chocolate, who were in vigorous competition with each other. Supermarkets of the modern kind had not yet arrived. (*ECL*)

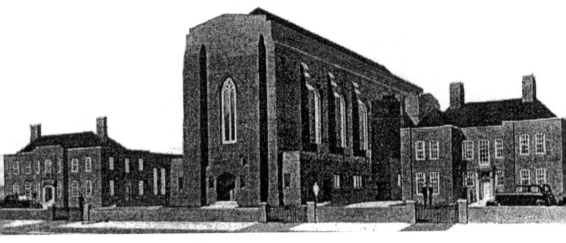

St Elisabeth's Church, Victoria Drive

Parts of Eastbourne that were well away from the coast continued to develop in the inter-war period. This church in Victoria Drive ministered to the needs of a new public. Its external appearance attracted (and still attracts) much adverse comment. The columnist Argus in the *Eastbourne Courier* observed in 1938 that 'I have yet to meet a person who finds the exterior pleasing or a person who finds the interior unpleasing'. (Canon Tony Delves, 'A Blot on the Landscape?', *Eastbourne Local Historian*, 153, Autumn 2009)

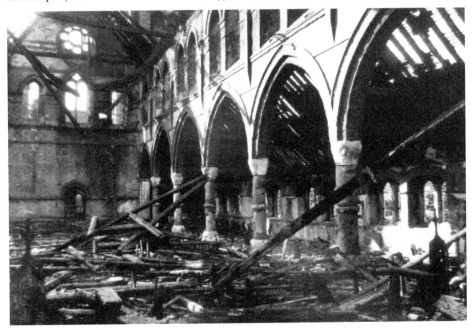

All Saints Church, Carlisle Road, After the 1927 Fire

One Eastbourne church suffered a disastrous fire in 1927. This photograph of All Saints church, which had been consecrated in 1879, not only shows the damage, but also gives an indication of how splendid the interior had originally been. Like most Eastbourne churches that had been built in the late nineteenth century, it was designed for a large congregation, the large majority of them living within easy walking distance. The church was later restored. (*ECL*)

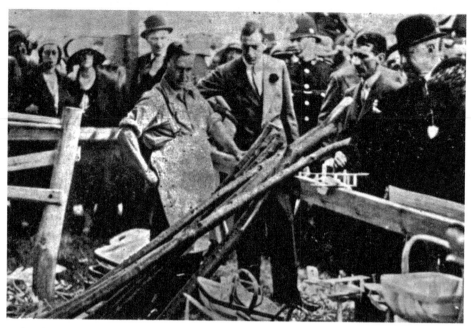

Duke of Kent at the Eastbourne Agricultural Show, 1932
Although Eastbourne had long been a seaside holiday resort, and was acquiring a growing volume of light industry, it was, and is still, the centre of a predominantly agricultural part of Sussex. Agricultural development was encouraged at specialist shows. One of these shows was patronised by the then Duke of Kent; the future King George VI. (*ECL*)

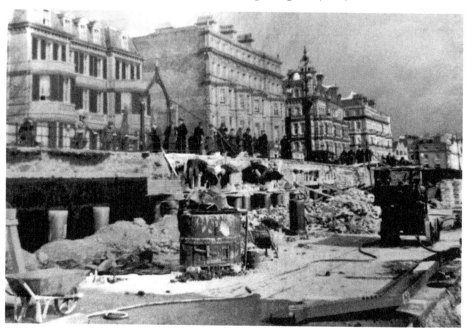

Construction of the New Bandstand, 1935
The old 'birdcage' bandstand was replaced by a much larger, and better sheltered, structure with adequate seating for more numerous audiences. (*ECL*)

8

Living Memory

When war came again in 1939, the experience of Eastbourne was very different from the previous conflict. Casualties, though severe, were considerably lighter, but the physical damage to the town was extensive. From mid-1940 onwards, there was a very serious threat of invasion. It was thought that Eastbourne would certainly be targeted by the enemy, and there were massive preparations to resist a possible attack. As with other seaside towns in South East England, Eastbourne's facilities for the seasonal holiday trade were much reduced, and access to the beach was greatly restricted.

Since 1945, the pattern of Eastbourne's life has changed greatly, and photographs provide an illustration of what has taken place. New occupations, including light industry, have developed and continue in the season when tourism is at a low ebb. There has been a big change in tourism. Before 1939, the vast majority of British people spent their holidays in their own country. But by the 1960s, a family holiday in the Mediterranean, usually involving air travel, became very common.

This might have been disastrous for Eastbourne's holiday trade, but other changes more than compensated. Growing affluence and the vast increase in car ownership meant that a day or weekend trip to the coast, often at very short notice, was within reach of most British people. Pensions meant that increasing numbers of elderly people no longer lived in poverty or dependence on others, but were able to contemplate retirement to a town like Eastbourne. Service trades and shops in Eastbourne no longer experienced such sharp bumps and slumps as they had known in pre-war days. The town's population rose sharply. All of this led to many changes in the appearance of Eastbourne. Great numbers of new houses and flats have appeared, most particularly in the east. Many of these are on the once rather desolate area known as the Crumbles. Shopping has changed dramatically with the appearance of supermarkets and shopping centres. New roads and car parks have been made for the now ubiquitous car.

There have been some adverse changes as well. A few of the new buildings erected since the war are widely regarded as monstrosities. The civic status of Eastbourne, once a county borough, has been reduced, and it is now dependent on other authorities for many functions. Road communications with other important places have certainly improved, but most local people would almost certainly agree that they are inadequate for growing modern needs. Rail travel is a little more comfortable, though a lot more expensive, than in pre-war days. Commuting is more widespread.

This chapter can only give a most cursory and subjective glimpse of what has happened to post-war Eastbourne.

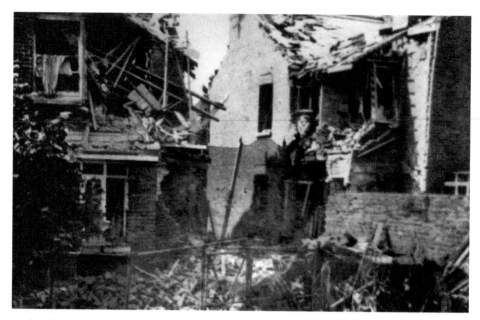

Backs of Houses in Whitley Road, June 1940

The bombardment of Eastbourne took place in several phases. The first phase followed immediately on the fall of France in June 1940. It was apparently designed to induce Britain to withdraw from the war and later (when this proved impossible) to soften up southeast England in preparation for a German invasion. Later in the war, the main objectives seem to have been to undermine domestic morale in Britain and, perhaps, to sustain morale in Germany. (*ETH*)

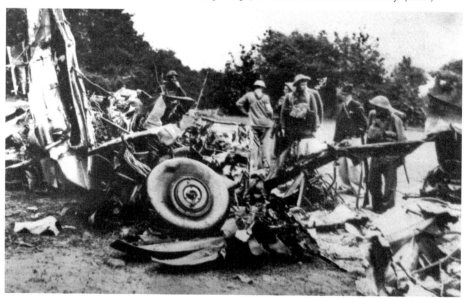

A German Bomber Brought Down in Eastbourne, August 1940

By August 1940, the Battle of Britain was at its height and many aerial dog-fights took place, often between German bombers and British fighters. These were watched with great interest by people in south-east England. Any German planes brought down were inspected by the military authorities and (so far as was permitted) by a gloating public. (*ETH*)

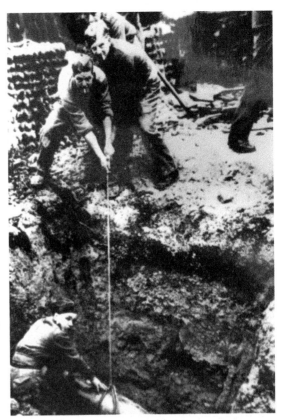

Right: Recovering an Unexploded Bomb
The war occasioned many acts of bravery,
but an exceptional measure of cool courage
was displayed by squads who recovered
unexploded bombs. Two of the men in
this photograph are smoking cigarettes. At
that time, the very serious threat posed to
health by smoking was not known, and the
practice was even encouraged. (*ETH*)

Below: Effect of Bombardment on a
Gasholder at Elms Gasworks, May 1942
The May 1942 bombardment of Eastbourne
also resulted in a direct hit on a gasholder.
Remarkably, there is a photograph taken
just after the incident, showing billowing
smoke. The second photograph shows the
twisted wreckage of a gasholder once the
fire had ceased. (*ECL*)

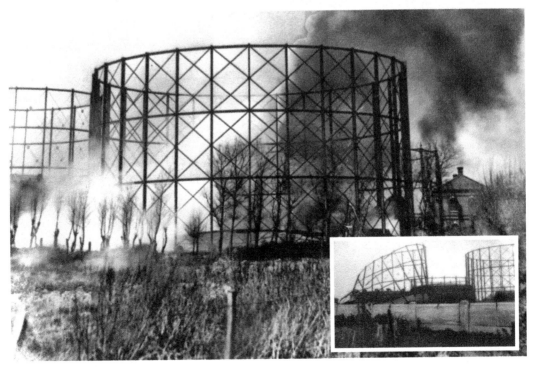

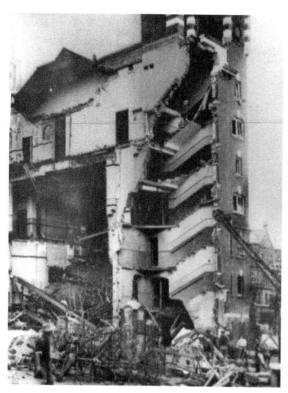

Left: **Eastbourne Technical Institute, June 1943**
The Technical Institute and associated public library, whose origins were seen in an earlier photograph, was destroyed by a bomb in June 1943. (*ETH*)

Below: **Jevington Gardens, 1964**
The bombardment of Eastbourne during the war did not destroy whole swathes of buildings as in some towns, but it left many awkward gaps. When rebuilding became possible a few years later, it was sometimes difficult to decide how those gaps were to be filled. Should one follow, so far as possible, the old designs, or build something in a more contemporary style? This photograph of Jevington Gardens shows how the problem was met in one place. Readers will decide for themselves whether the arrangement should be approved. (*ECL*)

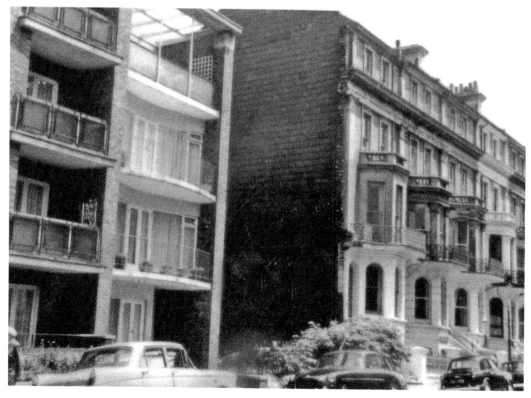

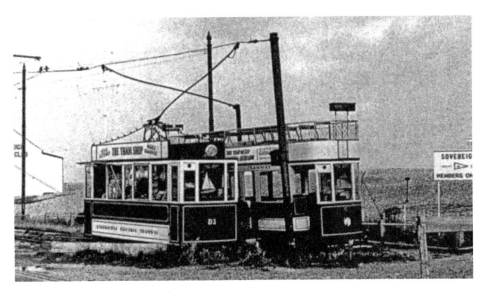

Crumbles Tramway, Prince's Park Terminus, 1954
In the late nineteenth and early twentieth centuries (the great days of tramways) most large towns had extensive networks. Eastbourne, however, steadily refused to adopt the tram. It is surely ironic that in 1954, when most of those tramway systems had been, or were being, scrapped, Eastbourne acquired its first trams, which ran from the eastern part of the front to the Crumbles. The trams were open-top vehicles; a holiday attraction rather than an everyday system of transport. The 'Crumbles Tramway' does not appear to have been a great success, and terminated in 1969. (*Eastbourne Buses 1903–2003: A Century of Service to Eastbourne*)

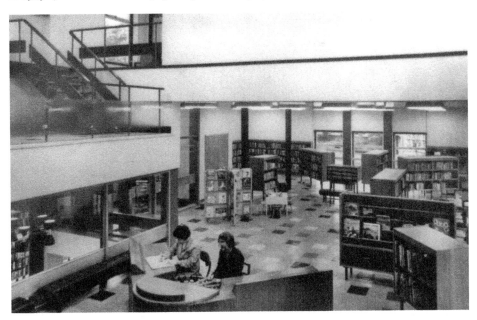

Children's Library, Central Library, 1964
Destruction of the Technical Institute and the associated public library during the war made new library arrangements essential. In 1964, a new central library opened at the corner of Grove Road. (*ETH*)

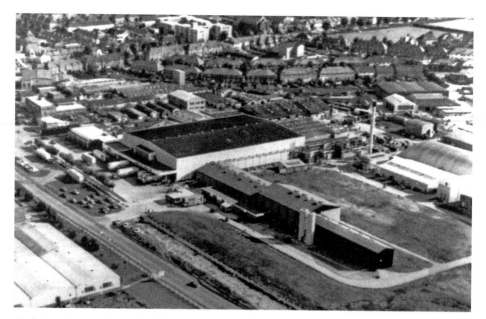

Bird's-Eye Factory, Lottbridge Drove
The area to the east and northeast of central Eastbourne has been greatly developed since 1945 for residence, shopping and industry. This large food factory was one of a considerable number of industrial developments that appeared. It will be noted that there are many post-war houses nearby. (*ETH*)

Building of the New Tesco, Lottbridge Drove
Many large shopping centres were also established in the area east and northeast of central Eastbourne. They relied on the presence of a large number of customers with cars who travelled from all parts of Eastbourne and other places as well. One of the new developments in Lottbridge Drove is a Tesco supermarket. (*ECL*)

South Cliff Tower

This is a modern photograph of what is probably the most controversial building in Eastbourne. A local councillor, Mrs Underhay, submitted plans for building a tower block of luxury flats. There was much protest. Mrs Underhay was later appointed mayor, and was in office in 1966 when the tower was completed. At the time of the ensuing council elections, custom held that the retiring mayor should be unopposed. In this instance, however, local feeling was so strong that an independent candidate was advanced against her, and was victorious. South Cliff Tower is undoubtedly a very desirable residence, commanding wonderful views, but many people consider it an excrescence, clashing violently with the general architecture of the vicinity. Even when viewed from hills several miles away, it stands out sharply from the rest of the town.

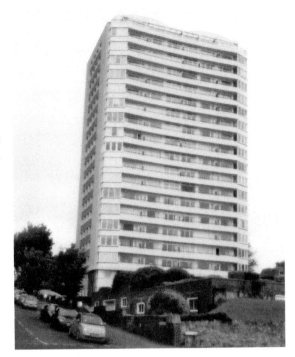

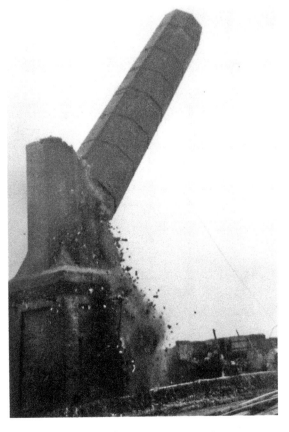

Demolition of Destructor Works Chimney, April 1967

Just as new enterprises have appeared, so also have old ones been removed. The enormous post-war growth of interest in the environment, and particularly in clean air, has led (in Eastbourne as elsewhere) to the end of operations which once generated noxious gases, particularly in the vicinity of towns. (*ECL*)

Sussex Gardens, East End: Now the Entrance to Arndale Centre
An important feature of post-war Eastbourne, as of many other towns, has been the development of major shopping centres, often close to the middle of the town. The big new shopping centre in Eastbourne is the Arndale Centre. This has necessitated radical changes to the attractive Sussex Gardens which bordered Terminus Road, while much of Terminus Road has been established as a pedestrian precinct. This photograph shows part of Sussex Gardens before the changes. (*ETH*)

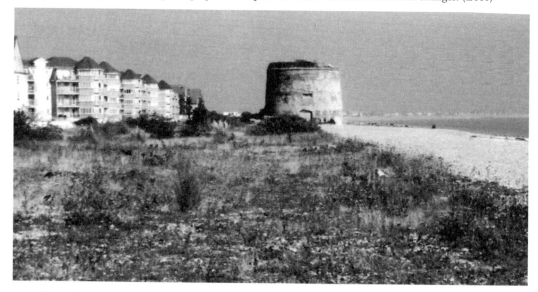

Sovereign Harbour and Crumbles
The most remarkable post-war development in Eastbourne has been Sovereign Harbour, which was mostly constructed in the 1990s. This modern photograph gives an indication of both modern buildings and how the area looked before development began. The part which is unchanged is a vestige of the Crumbles, and has been deliberately preserved for its ecological importance. In the middle of the picture is a surviving Martello Tower.

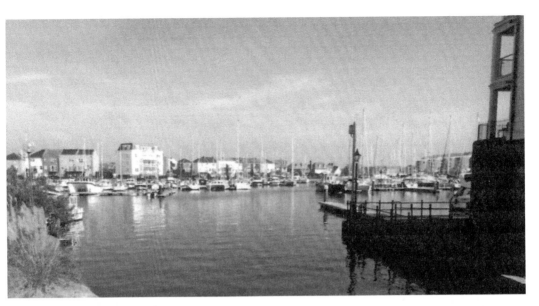

Sovereign Harbour: Further in
Many different kinds of development have taken place at Sovereign Harbour. This modern photograph shows one area where pleasure boats are moored. The buildings are all modern and their architecture is of mixed styles – deliberately so. In other parts of the Sovereign Harbour development there are many flats, and there is also a restaurant area.

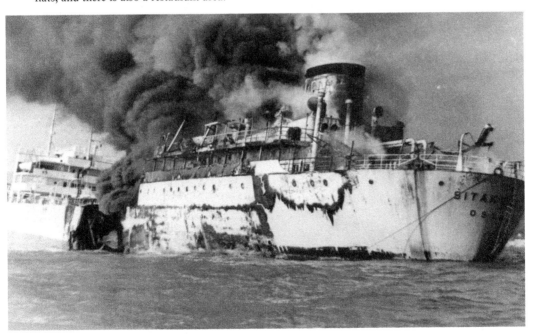

SS *Sitakund* Wreck, October 1968
Vessels carrying huge quantities of inflammable material are prone to disaster, which sometimes results in much damage over a wide area. The oil tanker *Sitakund* sustained several explosions and eventually came to rest not far from Holywell. Several years elapsed before it was possible to remove all the wreckage. (*ECL*)

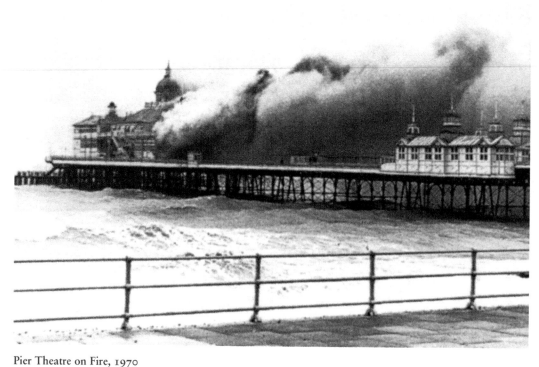

Pier Theatre on Fire, 1970
The theatre at the far end of the pier had been the source of much entertainment for many years. It
burnt down in a disastrous fire early in 1970.

9

Fringes of Eastbourne

Wannock Glen, *c.* 1910
One of the most attractive footpaths in the Eastbourne area is the little-visited, half-mile stretch of Wannock Glen, between Wannock and the hamlet of Filching. Once there was a restaurant and dance hall near the Wannock end, spanning the Filching Stream. Its foundations may still be seen. (*ECL*)

Pevensey Castle, Western Entrance to Roman Wall, Late Nineteenth Century
Most remarkable of the immediate environs of Eastbourne is Pevensey. The large castle site is nearly surrounded by a wall dating from Roman times. It appears to have been built in the late third century, while in the fourth century it formed part of the defences of the 'Saxon Shore', and was known as *Anderida* or *Anderitum*. After the Romans departed at the beginning of the fifth century, *Anderida* continued to have some defensive function. for the native population, bit in AD 491, the bands of two Saxon warlords massacred the inhabitants. Originally, entrance to the Roman enclosure was through a building set between the two towers shown in this photograph. (*ECL*)

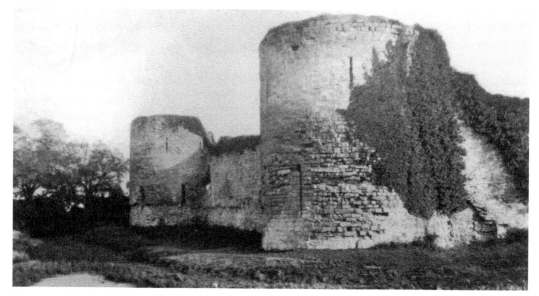

Towers, Walls and Moat of Medieval Castle at Pevensey. Postcard of 1926.
Roman *Anderida* was probably used by William the Conqueror in 1066 to protect his troops after landing nearby and before they engaged with the Saxons at the Battle of Hastings. Soon after the Conquest, defences of timber and earth were built within the Roman walls. A century or so later, the first stone building was constructed, but it was later altered considerably.

Pevensey: Old Town Hall and Village in the Late Nineteenth Century
Pevensey was an incorporated town from Norman times, until 1883. The former town hall, and several other interesting old buildings in the village, are still preserved. (*ECL*)

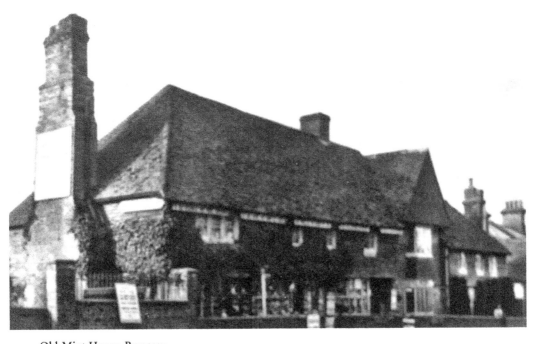

Old Mint House, Pevensey
The Mint House at Pevensey dates, in parts, from medieval times. The town must have been of considerable importance for permission to be granted to strike coins. (*ECL*)

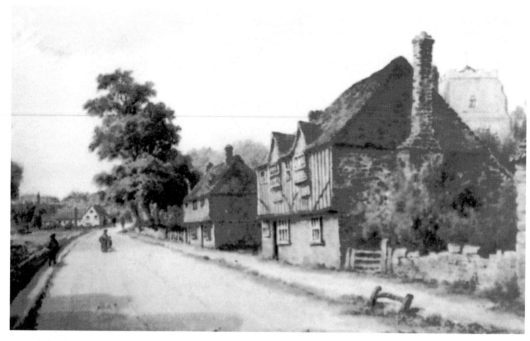

Westham, 1780
A very attractive street in the village of Westham, which lies immediately to the west of Pevensey, a short distance from the present boundary of Eastbourne Borough. (ECL)

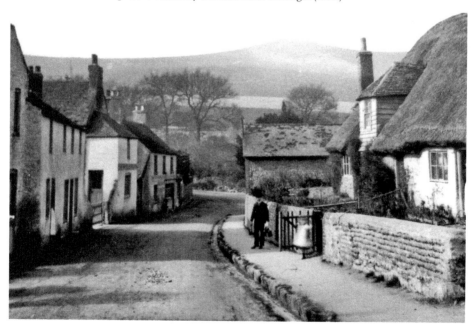

Willingdon in the Late Nineteenth Century
The older part of Willingdon still preserves much of its village character. Scenes, not very different from this, may still be seen there. Lower Willington, which is essentially a modern suburb, links directly with the northern part of Eastbourne. (ECL)

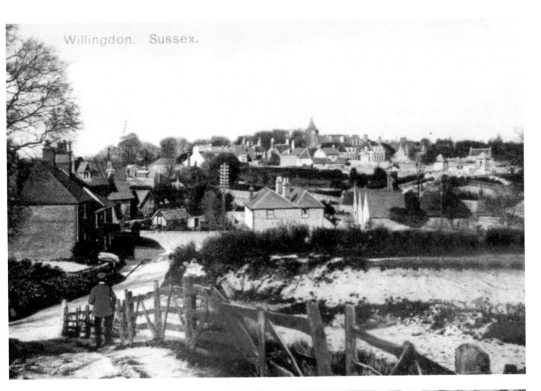

Above: Postcard of Willingdon, Sent 1910
Picture postcards usually show summer scenes; this is an exception. By contrast with the previous photograph, this one shows a number of houses which, at the time, were of quite recent date. Parts of Willingdon were already being developed as a dormitory of Eastbourne at the beginning of the twentieth century. (*ECL*)

Right: John Mewett, Saddler, at the Red Lion Inn, Willingdon, *c.* 1898
Old crafts were still preserved in the late nineteenth century, and beyond, in those parts of the Eastbourne district that had not become a mass of modern houses. (*ECL*)

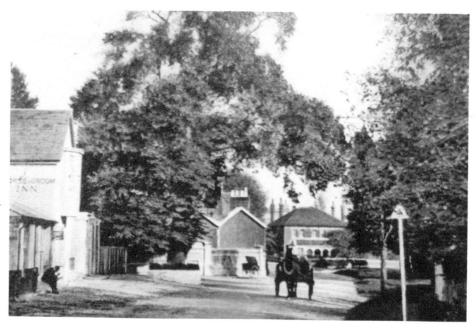

Polegate, Postcard from 1907

Until the railways arrived, Polegate was a hamlet belonging to Hailsham, the main part of which is several miles away. Polegate's appearance had already changed considerably when this picture was taken, and would later change again. The Horse and Groom pub has been altered greatly, but the old tree in front is still flourishing. (*ECL*)

High Street, Polegate, Early 1960s

Other parts of Polegate have changed radically in more recent times. It is striking, however, that these very modern-looking shop fronts were photographed half a century ago. (*ECL*)

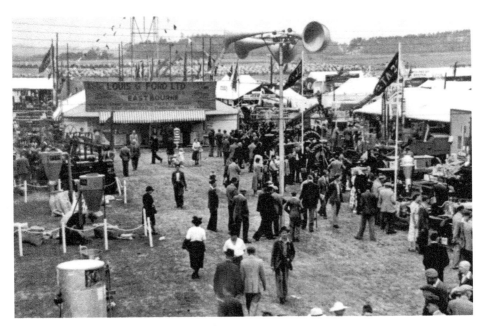

Sussex Agricultural Show, Priesthawes, Polegate, 1951
The strong link between Polegate (and other parts of the Eastbourne conurbation too) with agriculture has continued, despite all the changes. The Eastbourne conurbation is a good venue for displays of this kind. (*ECL*)

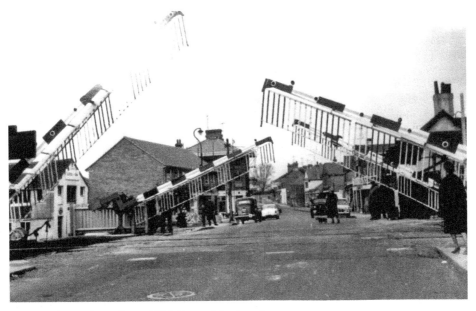

New Level Crossing Polegate High Street, March 1963
Important changes took place in railway links at Polegate in the 1960s. The old line northwards through Hailsham was closed, and is today represented by a useful route for pedestrians, cyclists and horse riders, known as the 'Cuckoo Trail'. Polegate station was moved some distance westwards. The new station is immediately adjacent to the view in this photograph. (*ECL*)

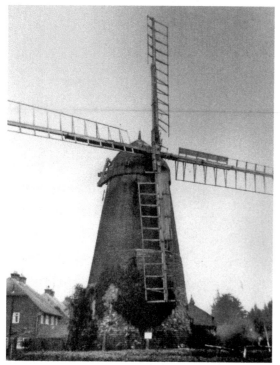

Polegate Windmill, Early 1960s
Kipling's allusion to the 'broad and brookless vales' of Sussex is not quite accurate, for there are many streams in the Eastbourne area. Yet in earlier times, there was not enough water power at the various local water mills to grind all the grain required to feed the people. There is, however, plenty of wind, particularly on the higher ground, and there were once many windmills. A few, including the one at Polegate, are still in working order. (*ECL*)

Wannock Gardens Entrance
Wannock, which adjoins Polegate, was the site of well-known gardens, which were often visited by excursions in former times. Wannock Gardens persisted until a few decades ago, when they were destroyed to make way for housing. (*ECL*)